color
graphics

ROCKPORT

Karen Triedman & Cheryl Dangel Cullen

color
graphics

the power
of color in
graphic
design

ROCKPORT
PUBLISHERS

First published in the United States
of America by
Rockport Publishers, Inc.
33 Commercial Street
Gloucester, Massachusetts 01930-5089
Telephone: (978) 282-9590
Fax: (978) 283-2742
www.rockpub.com

Library of Congress Cataloging-in-Publication data available

ISBN 1-59253-089-3

10 9 8 7 6 5 4 3 2 1

Design: Stoltze Design
Cover Image: Stoltze Design

Printed in China

I very much appreciate all the time and efforts of those who made contributions. Thanks to Kristin Ellison, Ann Fox, and all persons at Rockport who were part of the process. Also thanks to Herb, Steven, Lani, and those who allowed me time to work. A special thanks to my husband and daughters, whose patience and support made writing this book possible.

–Karen Triedman

Contents

Introduction

Communication strategy, the essence of graphic design, can be jeopardized by poor color choice. Because written words register in the viewer's brain after it responds to color, strong choices are intrinsic to a great design. Although on a functional level it creates reflectivity, visibility, contrast, and enhances legibility, color can and should also be used to entice people, enhance a concept, twist a message, or convey a feeling or emotion.

As designers, we have been exposed to color theory, but we may find it difficult to expand our theoretical understanding into the realm of practical use. Although we may understand that a composition based on a pair of complements will create harmony, we may not understand which pair will increase the communicative powers of the design. In the same fashion,

proportional balance between colors is obvious, but it is the way we manipulate the relationship to create the balance or imbalance that adds to or takes away from the design. Standard theory suggests that all colors mixed together become gray, but it takes more sophistication to see that the combination could be used to represent the blending of two corporate organizations.

Although choosing simple color palettes might be second nature, correctly choosing a color scheme that will evoke calmness or anxiety may be more difficult to ascertain. Because color communicates, we must be concerned with what our choices are communicating. An increased understanding of people's response to certain colors, both nationally and abroad, will help us to convey our message on a psychological or emotional level.

A sophisticated design person can use color to his or her advantage by understanding the implications that it has beyond attractiveness that supports a design strategy. Although I cannot provide the years of experience and training that it takes to develop the finesse involved in color application, I can present examples of what I consider to be interesting and creative color solutions to various design problems. I hope that *Color Graphics* provides you with ways in which you can learn to appreciate and use color to support your own work in the future.

–Karen Triedman

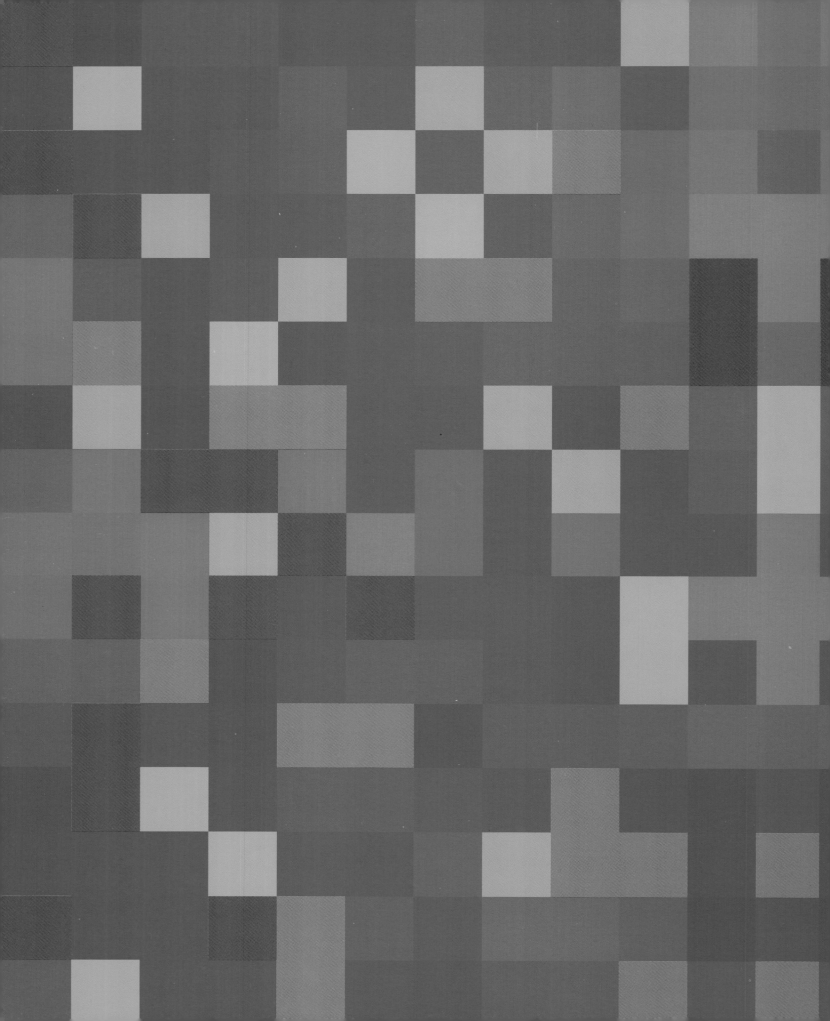

Color That Persuades

In our visually boisterous world, color is the key element that can be used to catch the viewer's attention. Whether bright or dull, singular or complex, physiological or psychological, theoretical or experiential, the persuasive power of color attracts and motivates a sale.

Although some colors produce an intrinsic physiological response—such as the way red increases your heart rate—most color response is due to experience and association. Persuasive color distinguishes one product from another, identifies the product, or associates the product with a similar brand name or category. Often, positive color associations increase the comfort level of the buyer. In the case of Cici's Pizza, designed by Design Forum, red and green are intentionally used to create an association with Italy and convey the idea of good Italian food.

There are palette associations for industries, product types, and geographical areas that can be used to support or authenticate a product or service. You might be persuaded to trust a bank that

uses blue in its logo and collateral materials because sound financial institutions often rely on blue to communicate stability and trust. The same approach is used for the Ellipsis catering menu designed by Dinnick and Howells. A natural color palette is supportive and consistent in that it suggests "homey and pleasant healthy food."

In addition to association, color can be used to identify a product. In the case of the Soho Spice restaurant in London, designed by Lewis Allen of Fitch, regional colors of India are used to identify the restaurant with its country of origin. The colors of Indian spices are also incorporated into the design. The spice colors create a taste–smell–visual association. The color allows people to see the taste and smell of Indian food.

A persuasive color palette can distinguish a product from its peers. Mires, in the piece Packaging System for Qualcomm, distinguishes its telephones by the use of fashion models and intense color. The high contrast "techno slick" colors against the monochromatic models and black

background increase overall image clarity. The boxes, when stacked together, make a strong visual statement causing the buyer to stop, look, and purchase.

Whether it's used in a product or an environment, persuasive color creates an association or identification, and it is the color that raises the comfort level for the purchaser of a product or service. As a result, it's the way color is used that distinguishes a product from comparable products and makes it sell better and faster.

FRANKFURTER SCHULTHEATERTAGE POSTERS

Client	Kuenstlerhaus Mousonturm, Frankfurt am Main
Design Firm	Büro für Gestaltung
Art Directors	Christoph Burkardt / Albrecht Hotz
Palette	Lime Green and Blue / Yellow and Turquoise / Blue and Pink

PROJECT DESCRIPTION

The client sponsors a two-week program of theater performances geared to children and needed lively posters to promote the event.

PROJECT CONCEPT

Because there were to be several different plays presented over the two-week period, using visuals that would attract the young audience could be confusing because they wouldn't necessarily relate to all the performances. Moreover, the posters were simply lists of the plays and dates presented. Instead of using graphics, color had to be the primary communicator to grab the attention of the young audience.

COLOR DESIGN

The design firm opted for a simple palette that would attract children with its lively, playful colors. The format remains consistent every year; only the color palette changes.

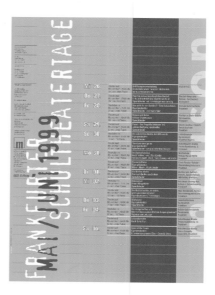

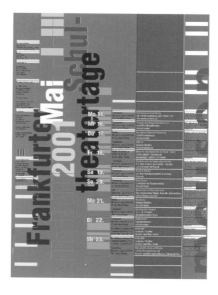

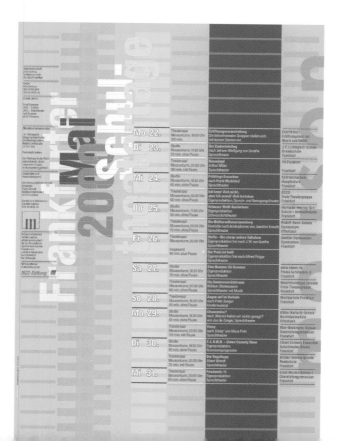

CREATIVE BLOC: 2001

Advertising Club of Dubuque	Client
Get Smart Design Co.	Design Firm
Jeff MacFarlane	Graphic Designer
Tom Culbertson	Illustrator
Orange / Green / Blue / Black / White	Palette

PROJECT DESCRIPTION

The Advertising Club of Dubuque tapped Get Smart Design Co. to develop the promotional materials for its 2001 creative conferences—which would be mailed directly to prospects in the hopes of getting them to sign up.

PROJECT CONCEPT

The design challenge was to find a way to cut through the mail clutter. Once it garnered the recipient's attention, the mailing needed to be strong enough to galvanize the recipient to complete the entry form and sign a check or fill in his or her credit card information. "With a limited number of mailings, we needed to attract a wide cross-section of attendees, [so] we selected powerful primary colors that could fight their way through stacks of direct-mail clutter," says Jeff MacFarlane.

COLOR DESIGN

"We attempted to brand the one-day conference through the use of color on mailings, signage, name badges, and the Web," MacFarlane explains. The result is a very simple series of direct mail pieces—here a postcard and a brochure—that are startlingly forthright. Simple icons and bold colors do all the talking.

Designers constructed the job with process colors in high percentages to stimulate action but never used more than two in any build.

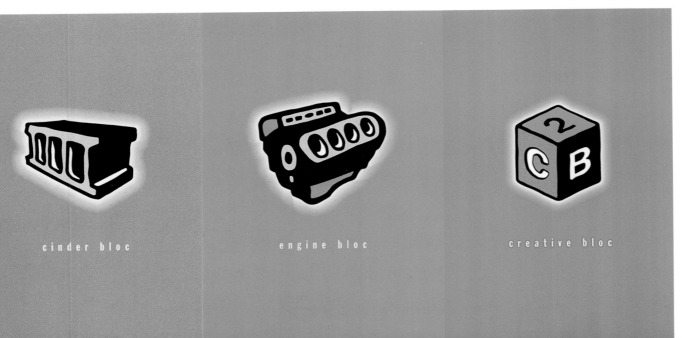

cinder bloc

engine bloc

creative bloc

BUCKY PACKAGING

Client	Bucky
Design Firm	Hornall Anderson Design Works
Art Director	Jack Anderson
Designers	Jack Anderson / Mary Hermes / Gretchen Cook / Henry Yiu / Elmer dela Cruz
Illustrator	Laurie Rosenwald
Palette	Blue / Yellow

PROJECT DESCRIPTION

Bucky manufactures travel neck pillows and similar accessories, so when the company needed a packaging concept for its products, Hornall Anderson Design Works set out to create something that had a comfy, dreamlike appeal.

PROJECT CONCEPT

The theme of ease and comfort extends beyond the superficial packaging; the packaging itself was redesigned to make it more user-friendly by allowing the consumer easier accessibility to the product. A Matisse-like illustration of a blue fluid body on each label was also thought to reflect a relaxing and comfortable feeling in keeping with the product's features.

COLOR DESIGN

Designers incorporated a fluid blue and yellow into the brand packaging. Blue was selected because it is associated with the sky and is cloudlike while generating feelings of softness, comfort, and peace. Yellow was chosen because it is thought to be friendly and warm. "Both colors illustrate attributes that make the product inviting and comfortably appealing to the consumer," says Jack Anderson.

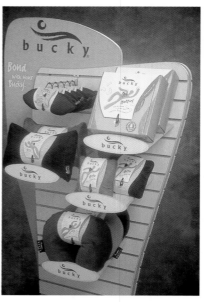

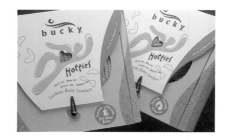

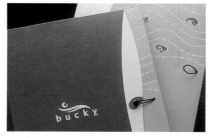

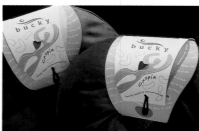

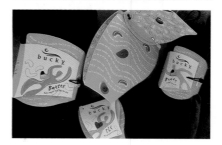

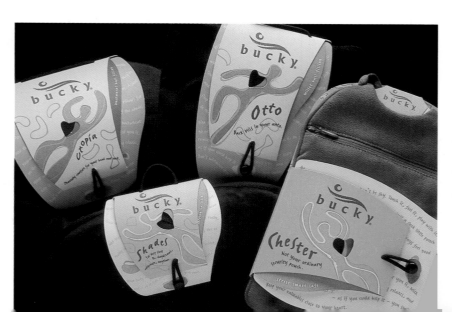

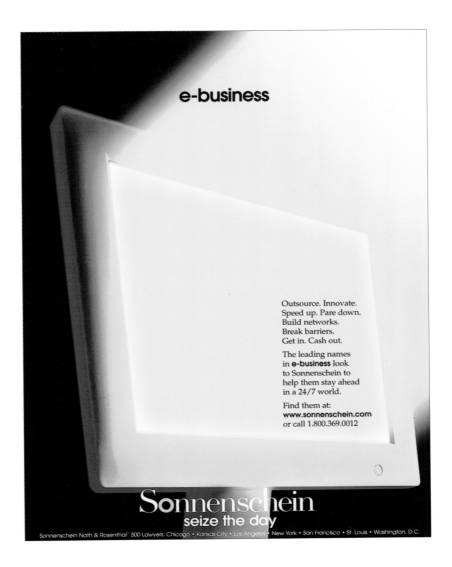

SONNENSCHEIN AD SERIES AND E-COMMERCE BROCHURE

Sonnenschein, Nath & Rosenthal	Client
Greenfield/Belser Ltd.	Design Firm
Burkey Belser	Art Director
Jeanette Nuzum	Designer
Yellow / Black	Palette

PROJECT DESCRIPTION

Sonnenschein, Nath & Rosenthal, a law firm, turned to Greenfield/Belser Ltd., experts in design for the legal profession, for a series of ads and an e-commerce brochure to spotlight their offerings.

PROJECT CONCEPT

Since the name *Sonnenschein* conjures up images of sunlight—which connotes knowledge and protection—designers liberally incorporated yellow into the advertising campaign as well as the promotional materials.

COLOR DESIGN

The use of the color yellow and other luminous objects succeeds in enhancing the connection between the firm's name, Sonnenschein, and the concepts of knowledge and protection, which characterize the firm. Consequently, although lots of colors are used in the e-commerce brochure, yellow runs consistently throughout it and all the marketing elements.

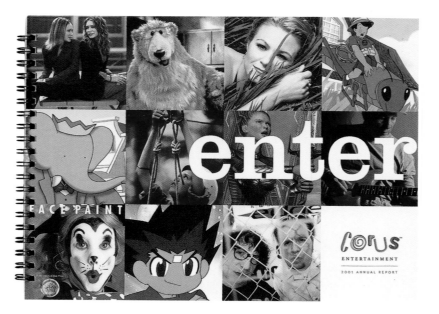

CORUS ENTERTAINMENT INC. 2001 ANNUAL REPORT

Client	Corus Entertainment Inc.
Design Firm	The Riordon Design Group
Art Directors	Ric Riordon / Dan Wheaton
Designer	Alan Krpan
Palette	Purple / Orange

PROJECT DESCRIPTION

Corus Entertainment, Canada's leading vertically integrated media and entertainment company, had only limited funds as compared to previous years to develop its 2001 annual report. For help, they turned to The Riordon Design Group to help them maximize their annual report budget.

PROJECT CONCEPT

Designers color-coded images on the report's cover using colors from Corus' identity, which they also designed. By doing so, they reinforced the brand, the properties it owns, and the products it produces. "It also expressed the vibrant and energetic culture of the company," says Ric Riordon.

COLOR DESIGN

Due to budgetary concerns, the interior pages were designed using two colors— purple and orange. Purple was used predominantly throughout the interior for legibility purposes, whereas the accent orange reflects the company's energy and progressive image.

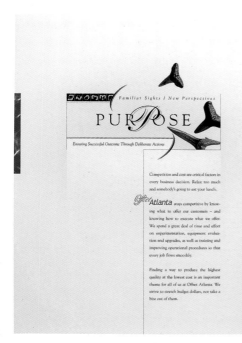

OFFSET ATLANTA MARKETING BROCHURE

Offset Atlanta, Inc.	Client
WorldSTAR Design	Design Firm
Greg Guhl	Art Director
Greg Guhl	Designer
Greg Guhl	Illustrator
Yellow / Blue / Red	Palette

PROJECT DESCRIPTION

Offset Atlanta, Inc., a printing company, wanted a marketing brochure that emphasized its full-color, full-service capabilities.

PROJECT CONCEPT

WorldSTAR Design selected photographs that when reproduced would provide maximum impact for each of the three primary colors—yellow, blue, and red.

COLOR DESIGN

"The dynamic images are displayed on a full-page, full-bleed layout opposite a page predominantly void of color printing," explains Greg Guhl. "The design effect creates a high-impact spread that screams color." Headings and images on each spread are embossed to provide a tactile element to the otherwise simple and clean design of the page. The pages are printed on one side only, then folded to eliminate the debossing effect on an unrelated page.

PRO BEAUTY PROMOTIONAL IMAGE FOLDER

Client: Pro Beauty GmbH
Design Firm: Braue Branding & Corporate Design
Art Directors: Kai Braue / Marcel Robbers
Designer: Marcel Robbers
Palette: Orange / Silver-Green

PROJECT DESCRIPTION

Pro Beauty, a cosmetic-surgery center, sought Braue Branding & Corporate Design's help in developing a marketing piece that would help dispel patient fears about surgical procedures.

PROJECT CONCEPT

Designers opted to use a warm orange color to help reach their goal. A warm orange, they reasoned, would create a warm and cozy feeling and, when incorporated into the unique design of the brochure, would emphasize the emotional component of how plastic surgery can help unfold a person's beauty. The slogan "We unfold your beauty" reinforced the physical aspects of the brochure, which "unfolds its wings like a butterfly."

COLOR DESIGN

The folder was laminated to give it longevity and add feeling. The secondary color palette—a silver-green—was carefully placed in a nondominant position to represent the medical aspect of the procedures, whereas the bulk of the brochure addresses emotional and psychological aspects of undergoing surgery. Together, the color palette and unique way that the brochure reveals itself work hard at persuading patients that plastic surgery is nothing to fear.

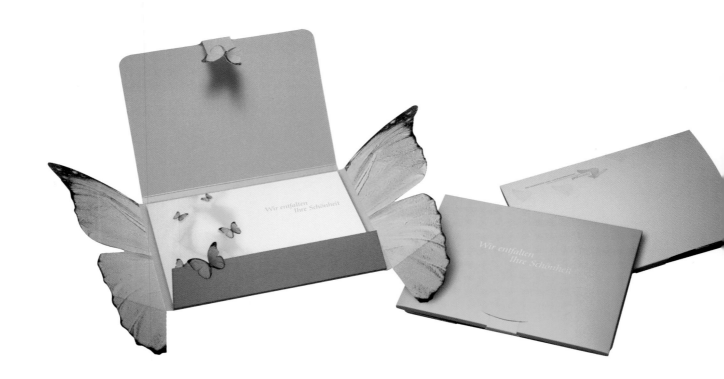

AIGA BUSINESS BREAKFAST SERIES

AIGA Washington, DC, Chapter	Client
Mek-Aroonreung / Lefebure	Design Firm
Pum Mek-Aroonreung / Jake Lefebure	Art Directors
Pum Mek-Aroonreung / Jake Lefebure	Designers
Cheryl Dorsett	Copywriter
John Consoli	Photographer
Red / Lime Green / Bright Cyan / Hot Orange / Tangerine Yellow	Palette

PROJECT DESCRIPTION

The Washington, D.C. Chapter of AIGA (American Institute of Graphic Arts) wanted to hold a breakfast seminar series. That meant finding a way to persuade designers that these seminars were different enough to warrant setting their alarm clocks extra early.

PROJECT CONCEPT

"The event was to be in the morning so we combined breakfast items and rise-and-shine colors to really grab the audience's attention and to let them know that this event was not going to be a typical morning lecture event," says Pum Mek-Aroonreung.

COLOR DESIGN

Designers decided to use a familiar break-fast item for each of four different post-cards included in the mailing. Next, they searched for fonts that would match the familiar type on each item, altered the type in Adobe Illustrator, and then re-created the individual letters as needed. The type, combined with the familiar color palettes, associated with each item made the re-created images dead ringers for the real things.

If anyone doubts the power of color to persuade and ring the bell of name recognition, consider the familiar red *K* on a certain breakfast cereal or the hot pink and orange packaging that holds donuts just perfect for dunking.

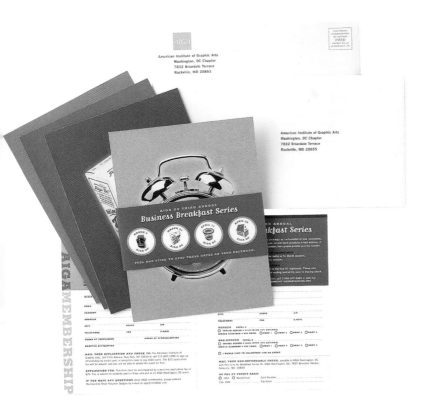

STOP HATE AT PENN STATE POSTER

Client Penn State Institute for Arts and Humanistic Studies
Design Firm Sommese Design
Art Director Lanny Sommese
Designer Lanny Sommese
Illustrator Lanny Sommese
Palette Black / White

PROJECT DESCRIPTION

"This poster was created in response to racial tension on the Penn State campus," says Lanny Sommese, designer. "The unrest was brought on by incidents that included threatening letters sent to a number of African-American students and faculty."

PROJECT CONCEPT

"A black-and-white palette was obvious," Sommese explains. "Black and white creates a sense of urgency. It gives the poster a 'hot off the press' newspaper look, which I enhanced by enlarging the dot pattern and awkwardly cropping the high-contrast photo of the hands and by the pasted-up quality I gave to the overall composition."

COLOR DESIGN

Adding to the feeling of urgency is the type, which Sommese cut out of paper by hand. "The hand-cut type is intended to add to the spontaneous appearance of the image and create a feeling of anarchy that I thought was appropriate," he says.

Posters were printed on a computer plotter printer, which allowed the university to print copies of the poster one at a time as needed, eliminating the expense of a large print run at the outset.

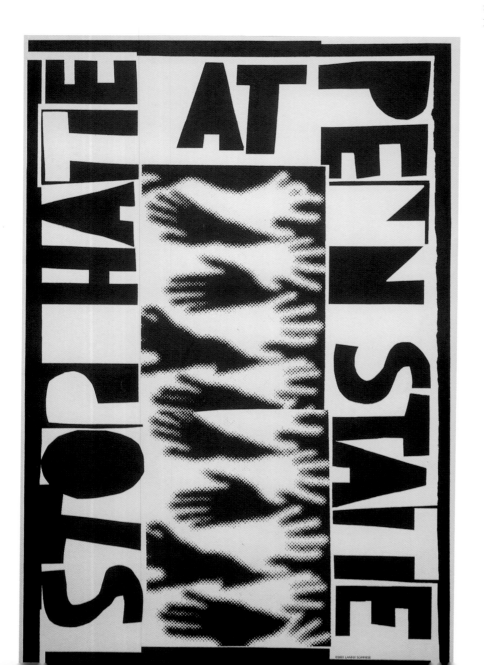

W.Y. CAMPBELL CORPORATE IDENTITY

W. Y. Campbell & Company	Client
Group 55 Marketing	Design Firm
Bill Campbell (W. Y. Campbell & Company)	Art Director
Jim Coburn / Jeannette Gutierrez	Designers
Richard Hirneisen	Photographer
Burgundy / Gold	Palette

PROJECT DESCRIPTION

W. Y. Campbell & Company, an investment banking firm, challenged Group 55 Marketing to develop a corporate identity that would persuade its audience that their firm could be trusted with personal investments.

PROJECT CONCEPT

"Investment banking is a serious business and when it comes to their money, people don't want to be shocked, titillated, or entertained. They want to be impressed and reassured," says Jeannette Gutierrez of the challenge in creating an identity system. With that in mind, Group 55 Marketing set to work with a palette of burgundy and gold and created a system that is understated, elegant, yet quietly reassuring.

COLOR DESIGN

"Gold, possibly the richest color there is, is used sparingly to suggest quiet wealth instead of glitziness," says Gutierrez. "Although burgundy is a very serious color, it has more warmth than say, dark blue, and that warmth suggests a high level of comfort and security for the investor who follows the guidance of W. Y. Campbell."

BROWNSTONES BROCHURE AND INSERTS

Client	FRAM America
Design Firm	Group 55 Marketing
Art Director	Jeannette Gutierrez
Designer	Jeannette Gutierrez
Illustrator	Suzanne Hayden
Palette	Olive / Bronze-Gold

PROJECT DESCRIPTION

FRAM America, a real estate development/management company, tapped Group 55 Marketing to develop a sales brochure for its property, Brownstones at the Vistas, an upscale residential development.

PROJECT CONCEPT

"We used color—olive green and bronze—to immediately convey a sense of luxury and serenity," says Jeanette Gutierrez. "The bronze-gold tone suggests tasteful luxury as opposed to flashiness, and the screened logo effect further suggests subtle richness. Olive green represents grass and lush greenery, but it is also subdued and restful."

COLOR DESIGN

Gutierrez specified a metallic ink for the job, which was printed on Potlatch Mountie Matte Natural in five colors—a four-color process plus match gold metallic.

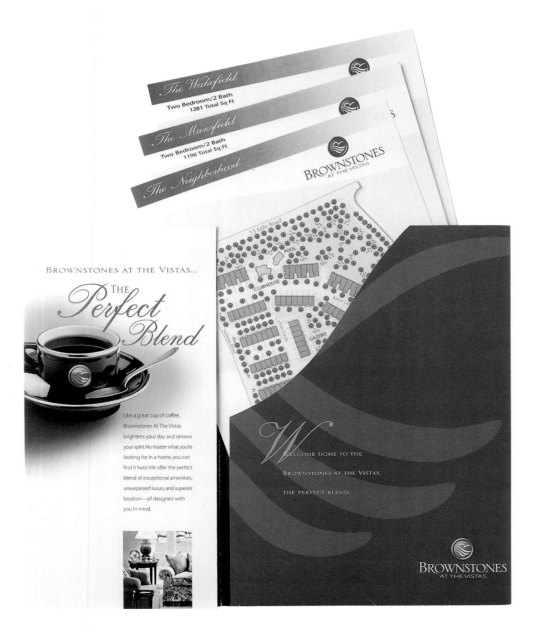

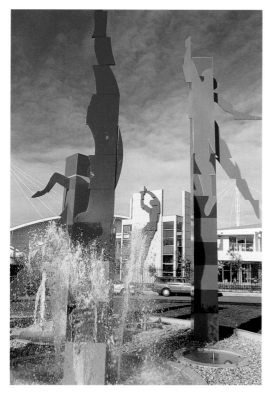

MELBOURNE SPORTS & AQUATIC CENTRE FOUNTAIN AND SCULPTURES

Melbourne Sports & Aquatic Centre	Client
Cato Purnell Partners Pty. Limited	Design Firm
Blue / Yellow / Red / Green / Orange	Palette

PROJECT DESCRIPTION

The Melbourne Sports & Aquatic Centre, a large sporting venue, needed exterior graphics that indicated an atmosphere of fun, yet the organization was very budget-conscious.

PROJECT CONCEPT

Cato Purnell Partners developed a series of three-dimensional graphics as sculptures, even one including a fountain, in a palette of lively colors that leaves little doubt that this venue is for fun.

COLOR DESIGN

Clean, primary colors were used to create an atmosphere of vitality. Geometric patterns of color allow one-color sports figures in action to stand out, whereas the three-dimensional aspect of the sculpture gives the figures movement and persuades passersby that this place offers plenty of action.

Color Forecasts– Where Do They Come from?

by Leatrice Eiseman

From international runways to America's own designer collections, the march of models in the latest trend of colors will ultimately wend its way into and greatly influence the color of interior furnishings, automobiles, and all other manner of consumer goods, including product packaging, advertising, Web sites, and point-of-purchase appeal.

The designers themselves are the real stars of the shows. They are very much attuned to and inspired by the hues they choose for any given season; they literally mold and manage color so that it attracts or titillates the consumer's eye.

Obviously, fashion designers feel that color is an integral element of their work and recognize its emotional tug at the consumer level. The colors that appear first in fashion will trickle down inevitably to other design sensibilities, including graphic design.

In this modern age of instantaneous global communication, the pecking order is not as rigid as in the past, when new colors were first embraced by fashion where they

remained firmly entrenched for several seasons (or years) before designers and manufacturers adopted and adapted them for other design areas. Today the crossover of colors can happen within a matter of days as graphic designers access and adapt to the latest trends.

In the late 1980s, environmentalism was gaining ground as a sociological issue that encouraged the use of recycled paper and discouraged the use of toxic chemical inks that were used in the bolder colors. As a result, nonbleached hues like beige and off-white became the colors of the moment in consumer goods, including clothing, home furnishings, packaging, and paper.

More recently, the graphic arts industry has spawned some of the most creative and unique color combinations and outrageous images that are constantly flashing on www.whatever.com. Colors bombard the public from a vast variety of other venues as well—from point of purchase to slick magazines, newspapers, catalogs, and billboards to the ubiquitous fashion reports on MTV, E! (Entertainment) Channel, and CNN. As a result of all of this exposure to

color, the consumer is more savvy than ever; he or she expects to see new color offerings in all products, so it behooves the smart designer to stay ahead of the curve.

To stay on the cutting edge of what's happening in color, it is imperative to understand the events that brought them to the forefront. From a purely psychological and sociological perspective, forecasted colors are inspired by many aspects of lifestyle. For example, when designer coffee became the rage in the mid 1990s, coffee browns came forward in every area of design.

It is the attitudes and interests of the public at large — not only through entertainment and fashion icons — and their important social concerns, needs, desires, fears, and fantasies that may spawn the newest color trends.

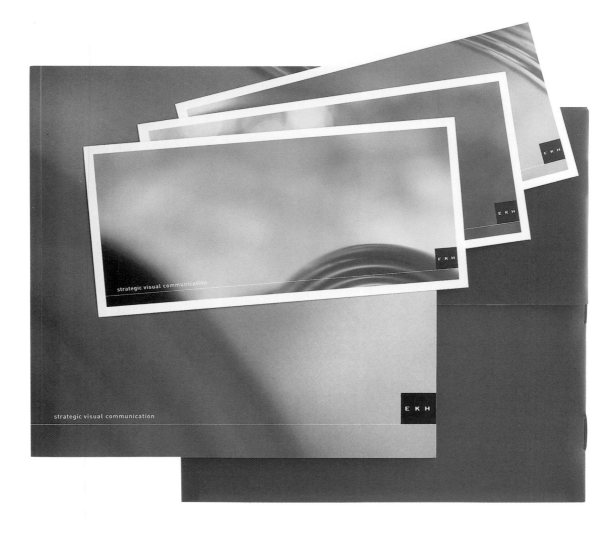

EKH CORPORATE PROFILE

Client	EKH Design
Design Firm	EKH Design
Art Director	Anna Eymont
Designer	Rebecca Lloyd
Photographer	Greg Havemza
Palette	Blue / Silver

PROJECT DESCRIPTION
EKH Design, an Australian design firm, tackled the job of creating its own corporate profile—never an easy task when a firm must evaluate its own products and services.

PROJECT CONCEPT
Designers photographed tin cans to symbolize different forms of communication and placed these images on the cover and introductory pages of the brochure. The abstract images "convey the creative nature of our business and the blue feel gives us a point of difference among other design businesses," says Anna Eymont.

COLOR DESIGN
Blue was chosen for the corporate profile because it communicates calmness, professionalism, and creativity, according to designers. Everything from the blue plastic envelope to the interior brochure carries the blue theme, which uses a variety of hues.

SEGA TRADE SHOW GRAPHICS PROMOTION

Sega	Client
Mires	Design Firm
John Ball	Designer
Cyan / Black / Red / Blue / White	Palette

PROJECT DESCRIPTION

Mires was asked to create an identifying graphic image to be used at a gaming industry trade show to promote Internet playing products. The image was to appear on everything from binders to banners.

PROJECT CONCEPT

Mires wanted to utilize Sega's previous success with its prime target market, twelve to twenty four, and employ graphics and color that were aggressive, mysterious, and borderline ghoulish. Using mystery and intrigue, these graphic features would entice Sega players to play online.

COLOR DESIGN

Although they wanted to keep within the color families of blue, red, and white, Mires adjusted and intensified the color, replacing royal blue and primary red with an intense cyan blue and hot orange. In addition to the evocative choices, color placement was crucial to the design. The unexpected blue field on the faces made them mysterious, whereas the hot orange on the type added a reference to computerized game playing.

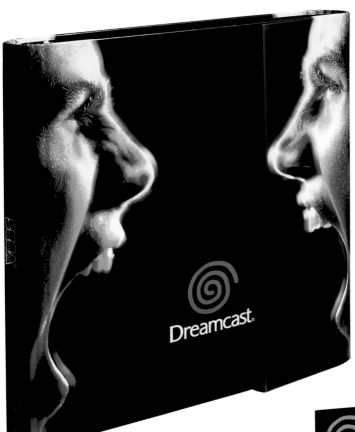

PACKAGING SYSTEM FOR QUALCOMM'S TELEPHONE

Design Firm	Mires
Creative Director	Jose Serrano
Graphic Designer	Deborah Hon
Palette	Warm Yellows / Greens / Warm Reds / Oranges / Cool Blues

PROJECT DESCRIPTION

Qualcomm worked with a design team headed by creative director Jose Serrano of Mires Design Inc., San Diego, California, to come up with a concept for marketing their telephone product.

PROJECT CONCEPT

The Mires concept involved changing the nature of how a telephone is marketed from a commodity to an attractive, impulse product. Rather than using corporate design and colors that presented the product as an accessory to a larger product system, Mires created packaging that had shelf impact. They achieved this by using models with an international flair with assertive poses and by using contrasting, high-intensity color.

COLOR DESIGN

By intention, Mires uses colors that are not corporate but are consistent with the international look of the graphics. On the sides of the box, the highly intense and somewhat techno-slick colors work to create contrast with the models that appear monochromatic. However, on the box top, the color submerges the ear and mouth body parts. Different palette groupings accompany different models. The visual variety gives the stacked items a colored blocklike appearance. Together they serve as a vivid point-of-purchase display creating a product that sells itself.

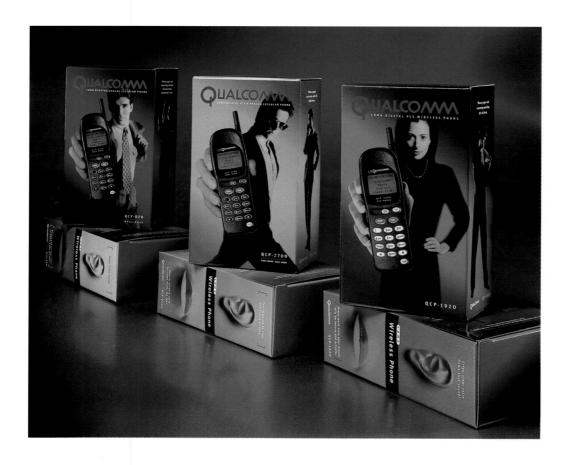

Cici's Pizza	Client
Design Forum	Design Firm
Bill Chidley	Chief Creative Officer
Olive Green / Rust	Palette

PROJECT DESCRIPTION
Cici's Pizza approached Design Forum, asking them to create a new brand identity for the restaurant. This brand identity included the redesign of the interior space in addition to all the collateral material.

PROJECT CONCEPT
The objective of the Design Forum team led by Bill Chidley was to create an identity for Cici's Pizza that would allow them to maintain their identity as an Italian pizza restaurant, but would draw them out of the fast-food realm toward a more upscale, family environment.

COLOR DESIGN
Although the colors of red and green, used by other pizza restaurants, were maintained, they were toned down throughout the restaurant and in the logo. The olive greens and rusts, which lean more toward a softer, quieter feeling, were used with the hope of making it a warmer, slower, family-eating atmosphere.

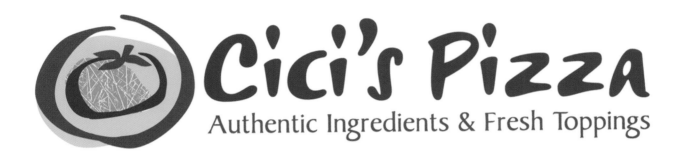

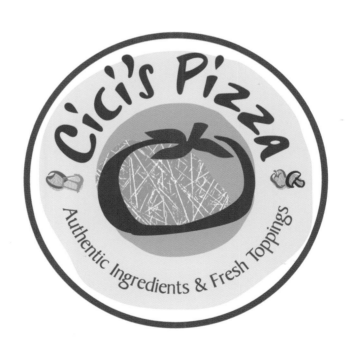

GENESIS, A STUDY IN MEANS, FRASER PAPER

Design Firm	The VIA Group
Art Director	Oscar Fernandez
Designers	Oscar Fernandez / Andreas Kranz / M. Christopher Jones
Copywriter	Wendie Wulf
Production	Shelly Pomponio
Palette	Browns / Tans / Greens / White / Gray-Blue

PROJECT DESCRIPTION

Fraser asked VIA to create a promotional piece that would increase awareness and, thus, reinvigorate the Genesis uncoated recycled product line. The target audience was senior management designers making essential paper selections for pieces such as annual reports, brochures, and fine books.

PROJECT CONCEPT

Working with the original product name Genesis, VIA used the nautilus shell as a symbol of balance, proportion, beauty, and visual order. The shell and the piece itself were representative of the continual transformation of natural materials according to the system of visual organization drawn from nature and man. The swatch book was also a demonstration piece for high-end printing techniques. In order to portray flexibility, the beautifully narrated book was created in a four-color process and was filled with many different printing techniques.

COLOR DESIGN

The theme of natural color is prevalent throughout the book. Type colors often matched the colors of the paper, and there is a list of paper colors in color-appropriate type on the last page. In addition to the use of neutral colors, primary color is used for visual excitement on the cover and throughout the book.

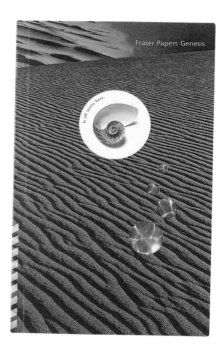

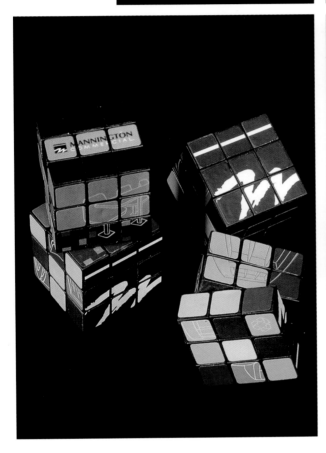

SAMPLE BOOKS FOR MANNINGTON COMMERCIAL

Mannington Commercial	Client
Supon Design Group	Design Firm
Supon Phornirunlit	Creative Director
Pum Mek-Aroonreung	Art Director
Todd Lyda, Jennifer Higgins, Todd Metrokin	Designers
Jae Wee	Illustrator
Dusty Purples / Blues / Orange / Green / Primary Red / Yellow	Palette

PROJECT DESCRIPTION

Mannington Commercial asked Supon Design Group, a Washington, DC, design firm, to redefine Mannington's product through swatch books and collateral material. Rather than being solely dependent on a consumer-based client, they wanted to expand their target market to include a more sophisticated group of architects and interior designers. Their primary purpose was to attract a more upscale clientele.

PROJECT CONCEPT

Supon Design Group used a series of line drawings of interior furnishings that were then superimposed on top of gridlike graphics. They created eight to ten designs that identified with a modern upscale target market. The idea was to create sample books that took color and design trends into consideration while creating pieces that would last up to ten years. The clean architectural renderings combined with the color graphics created a modern, timeless look.

COLOR DESIGN

The color and design served as a device to attract designers and architects to explore the Mannington product. Color worked integrally with the line drawings to create visual movement across the sample covers and within the architectural renderings. Toned-down colors are combined with a layering design technique to give the books a more corporate and professional look.

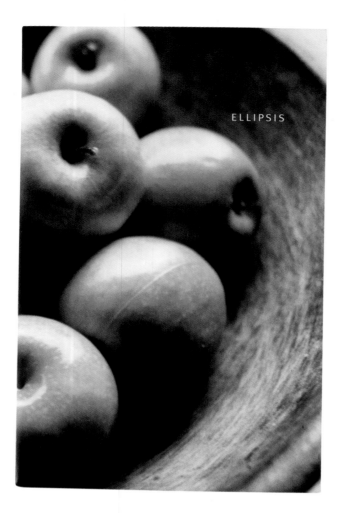

CATERING MENU FOR ELLIPSIS RESTAURANT

Client Ellipsis
Design Firm Dinnick and Howells
Graphic Designers Sarah Dinnick and Jonathan Howells
Palette Greens / Eggplants / Creams

PROJECT DESCRIPTION

Nancy Barone, proprietor of Ellipsis restaurant in Toronto, Canada, asked Dinnick and Howells to design a catering menu and business cards for their restaurant, which serves hearty and healthy foods. A neighborhood favorite, the eatery was designed in rich brown, earth tones, and white woods with a cream bar.

PROJECT CONCEPT

Using the menus and other collateral materials, Dinnick and Howells wanted to communicate the idea that "food and pleasure are synonymous. "Because they wanted to support the feeling of the restaurant, "which was created with the intention of combining high quality, classic cooking techniques and down to earth comforts," Dinnick and Howells came up with the idea of using warm, earthy food colors and antique dingbats from the restaurants as a pattern for the back of the menus and the business cards.

COLOR DESIGN

Soft, natural imagery and color supported the leaning toward health organic food. Rich eggplants and apple greens were used for the cover and business cards, whereas toned-down values of greens, blues, and creams were used for the back of the menu. Green-apple greens and grays were dominant colors in the photographic images on the back and front.

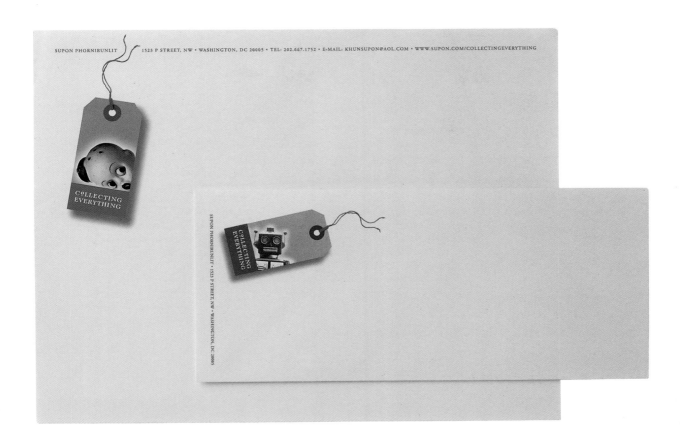

STATIONERY AND BUSINESS CARDS FOR A COLLECTIBLES COMPANY

Collecting Everything	Client
Supon Design Group	Design Firm
Supon Phornirunlit	Creative Director
Supon Phornirunlit	Art Director
Pum Mek-Aroonreung	Designer
Pum Mek-Aroonreung	Illustrator
Cream / Sienna Red / Blues / Browns / Greens	Palette

PROJECT DESCRIPTION

Phornirunlit wanted to design stationery and business cards for a hobby of his, an online collectibles company, Collecting Everything.

PROJECT CONCEPT

The branding concept involved creating a design that would reflect the nostalgic feeling of the collectibles. It combined a simple modern type and layout with a playful tag system in which different collectibles were highlighted.

COLOR DESIGN

While the stationery is cream, the tag color varies to reflect the piece itself or the time period in which it was made. A collectible made in the 1950s might have a tag color in pink, as pink was the fashionable color at that time.

SOHO SPICE—BRANDING CAMPAIGN FOR AN INDIAN RESTAURANT

Client	The Redfort
Design Firm	Fitch
Creative Director	Lewis Allen
Graphic Designer	Nick Richards
Palette	Deep Reds / Oranges / Yellows / Deep Blue

PROJECT DESCRIPTION

Amin Adi, owner of London's popular traditional Indian restaurant The Redfort, hired Lewis Allen of Fitch to create the environment for a second Indian restaurant with a slightly less traditional bent. The new restaurant was to cater to a younger population and high-end tourists.

PROJECT CONCEPT

Lewis Allen wanted to reinvent the idea of the Indian restaurant. He chose to derive the project concept from the colors and scents of Indian spices. In addition to the store design, the project included the design of menus, collateral material, and spice products. Informational cards were created to explain the spices, their origins, folklore, and their uses in recipes. The text, in a crisp white typeface, was lighthearted, and the cards were distributed freely. Menus were made of handcrafted paper with color bleeds.

COLOR DESIGN

Color inspiration for Soho Spice came from a combination of nontraditional Indian regional colors, which were combined with colors that reflected the richness of spices. The blue that is prevalent throughout the restaurant and collateral material came from the highly intense blue saris of the province of Rajasthan. The combination of colors was designed to invoke the "happy chaos of India." The spice labels and the cards also used intense color. The menu's handcrafted feeling was enhanced by bleed textures swiped through the food listings and the consistent blue background.

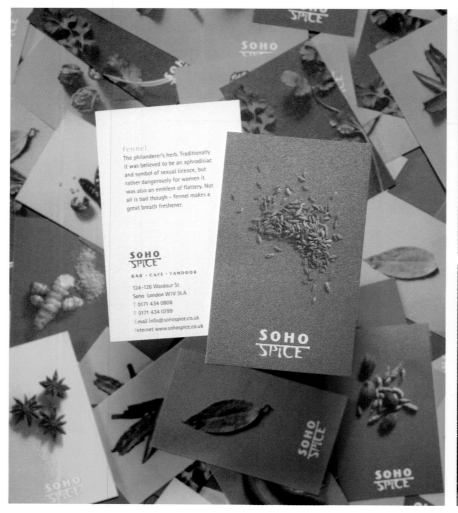

AN AWARENESS CAMPAIGN FOR YOSEMITE WILD BEAR PROJECT

Yosemite National Park Client
MOD/Michael Osborne Design Design Firm
Paul Kagiwada Creative Director
Purples / Blues / Deep Reds / Oranges / Greens / Brown Palette

PROJECT DESCRIPTION

Because Yosemite National Park workers were concerned with public behavior toward the bear population, they hired Michael Osborne Design to create a wild bear awareness campaign. The primary concern was warning people about the dangers of feeding bears and leaving food in their cars. T-shirts and posters were to be manufactured as part of the campaign.

PROJECT CONCEPT

The park wanted people to leave the bears alone, thereby keeping them wild, so Michael Osborne Design created a concept that revolved around the idea that bears are not friendly. Although the T-shirts and posters needed to be consumer-friendly, the image had to give the feeling of standoffishness. Graphics and color had to be used to distance people from the bears.

COLOR DESIGN

The color supports the seriousness of the bear issue. While the six colors are rich, dark, and muted, combined their discordancy creates an unsettled feeling. Because these discordant colors create a jarring, uncomfortable sentiment, the design succeeds in conveying a sense of danger.

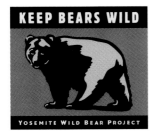
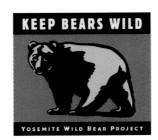
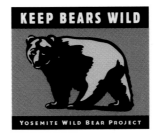
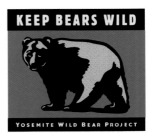

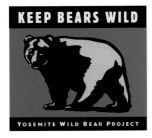
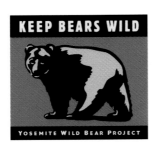
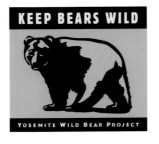
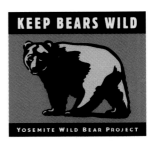

PEARL JAM CONCERT POSTER

Client	Pearl Jam
Design Firm	Ames Design
Designer	Coby Schultz
Palette	Hot Red / Lime Green / Blue

PROJECT DESCRIPTION

Pearl Jam hired Seattle-based Ames Design to create a series of concert posters for their last tour. Ames Design created a limited-edition silkscreen poster for each venue and the band sold them during the concert.

PROJECT CONCEPT

Coby Schultz used the concept of bold and prehistoric images placed in an unconventional setting to create a cool, avant-garde feeling. He wanted to enhance a feeling of spontaneity and excitement. The image was reinforced by using fluorescent inks and futuristic type. Schultz cropped the drawing so that it would take a minute for the viewer to see what was going on.

COLOR DESIGN

Schultz chose the fluorescent inks to intensify an already bold image and give the overall piece a futuristic feel.

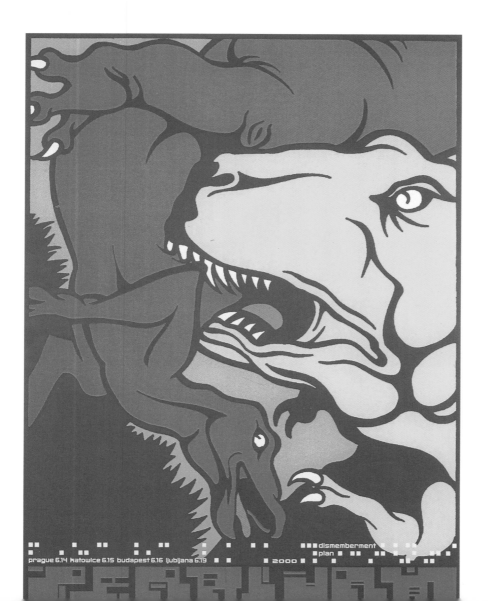

PRODUCT DEVELOPMENT FOR FACE À FACE

Face à Face	Client
Metzler and Associates	Design Firm
Mark Antoine Herrmann	Creative Director
Mark Antoine Herrmann, Fabienne Grosslerner	Graphic Designers
Greens / Purples / Pinks / Oranges / Turquoise	Palette

PROJECT DESCRIPTION

Face à Face, a French designer eyewear company with markets in Europe, Japan, and the United States, asked Metzler to create a new identity that included packaging and collateral literature. The product development reflected both the designer's attitude toward the clean and functional, while the product was perceived as part of the luxury business.

PROJECT CONCEPT

Metzler and Associates wanted to create a two-sided identity: one side with a clean, simple, and elegant logo and the other side with a bright and colorful look. The patterns stemmed from a lively interpretation of the former logo design.

COLOR DESIGN

Metzler chose a vivid fashion-based color palette that will change and evolve in a timely way with fashion trends. The stationery was created to provide great color contrast between the front and back and to inject an element of surprise into the product.

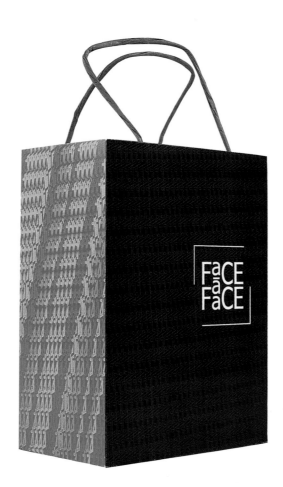

2

Color That Changes Your Perspective

Because the designer wants to alter the viewer's perception, color that changes a person's perspective is perhaps the most difficult and creative use of color in graphic design. It is difficult because the color acts as the antagonist for the change in perception and is integral to the strategy of the piece. It is the relationship between what is expected and what is actually presented that creates interest and excitement.

Color that changes your perspective can be at the basis of the design strategy. For example, VIA uses gray in the gofish.com logo to suggest a mixing and a union—rather than a transaction—between the buyer and the seller. KBDA creates a fun promotional piece that portrays the idea that clients and designers don't always agree on color selection or meaning. The relationship between the words and the colors are integral to the piece.

Color can also support and enhance an unusual design concept. In the Lee direct-mail piece designed by Fitch, a tribal tattoo design uses cutouts to reveal bright shirt colors beneath. It is the only bright color in the mailing. The Molecular Bio-systems

annual report by Cahan and Associates uses color to show a loose affiliation between subject matter and visual design. Although the color pink suggests human flesh, thereby giving the medical technology a human quality, it supports the design strategy by creating a low-intensity and low-contrast image.

Another way in which color can be used to change a person's perspective is to employ color that is intentionally different from the norm. In the Christmas CD mailed out for Albertsen and Hvidt, re:public used orange instead of red to represent a "controllable wild." "Incorrect color" was also used by Cahan and Associates in the Consolidated Paper book on annual reports in which green chapter heads replace corporate blue. The book itself has a chapter on corporate blueness, showing the intended choice of green. It is through that intentional manipulation of color that color changes a person's perspective.

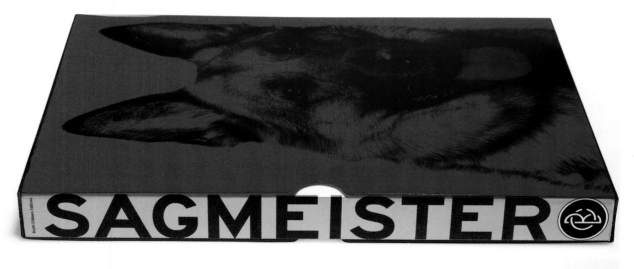

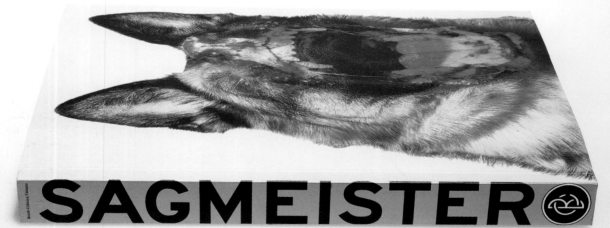

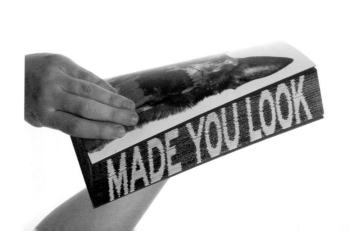

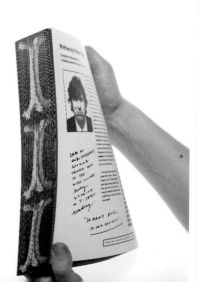

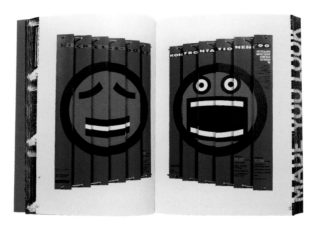

SAGMEISTER, *MADE YOU LOOK*

Booth-Clibborn Editions	Client
Sagmeister, Inc.	Design Firm
Stefan Sagmeister	Art Director
Stefan Sagmeister / Hjalti Karlsson	Designers
Kevin Knight	Cover Photography
Red / Green	Palette

PROJECT DESCRIPTION

Booth-Clibborn Editions, a publishing house, retained Stefan Sagmeister to design the cover for a book on his works that they were publishing. The publishing house gave Sagmeister plenty of creative freedom, promising that he would have creative control.

PROJECT CONCEPT

Sagmeister wanted to have fun with the book, which wasn't necessarily what he was expecting given the horror stories from other designers who had created books about their studios. They "told me it was the most difficult job of their lives," Stefan Sagmeister says. "It turned out to be the opposite. Fun."

It was intended to be fun for readers, too, and the book design echoed what Sagmeister's design has become known for—many interactive aspects and optical tricks. The cover is a prime example—Sagmeister uses a red filter device, which he had used previously on a client's CD packaging.

COLOR DESIGN

The calm dog is printed in green and then overprinted by the frantic dog in red. When this is placed inside a red printed plastic case, the green image turns black (because red and green are complementary colors) and the red image becomes invisible.

Sagmeister included other tricks in the book as well. "When you bend the book in one direction, the title, *Made You Look*, becomes visible on the fore edge; in the other direction, the dog gets something to eat," says Sagmeister.

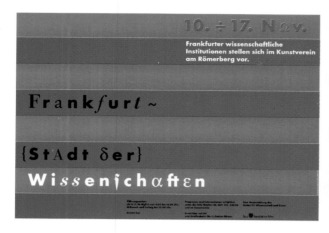
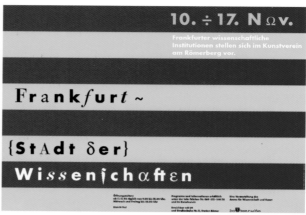

FRANKFURT—STADT POSTERS AND FLYER

Client City of Frankfurt am Main
Design Firm Büro für Gestaltung
Art Directors Christoph Burkardt / Albrecht Hotz
Palette Pink / Teal / Blue / Green / Yellow

PROJECT DESCRIPTION

Frankfurt—Stadt der Wissenschaften is an annual exhibition that features a wide variety of scientific institutions in Frankfurt, Germany, ranging from humane organizations to those in natural science. With so many organizations represented, the exhibition needed promotional materials that would build attendance.

PROJECT CONCEPT

Designers chose a color palette that would demand attention for these organizations that are often thought of as boring and staid. No tranquil palettes would do for this group; instead, designers took the opposite approach and went for a palette that screamed "Wow!"

COLOR DESIGN

"The colors attract attention to these often overlooked institutions as well as showing the wide spectrum in contrasting colors," says Albrecht Hotz.

YEAR OF THE DRAGON CARD

Team 7 International	Client
Julia Tam Design	Design Firm
Julia Chong Tam	Art Director
Julia Chong Tam	Designer
Julia Chong Tam	Illustrator
Green / Yellow / Fuchsia / Purple / Black / Gold	Palette

PROJECT DESCRIPTION

For Team 7 International's annual New Year's card, Julia Tam Design set to work on the Year of the Dragon design. She wanted to avoid depicting a black-and-white or gold dragon as is seen on most commonly used cards.

PROJECT CONCEPT

Not wanting the card to appear commonplace, Julia Tam decided to transform her dragon into a bright colorful one that intertwines with the numbers 2000. "Adding pattern in the numbers, checkers, stripes, dots, wiggles in bright, primary colors makes it not only colorful but interesting," says Tam. Gold foil adds an additional point of interest and panache.

COLOR DESIGN

The vibrant, rainbow-colored dragon with its interesting die-cuts and accordion folds stands apart from most Year of the Dragon visuals, which tend to stick to a palette of red, black, white, and gold. This card's differences make it memorable.

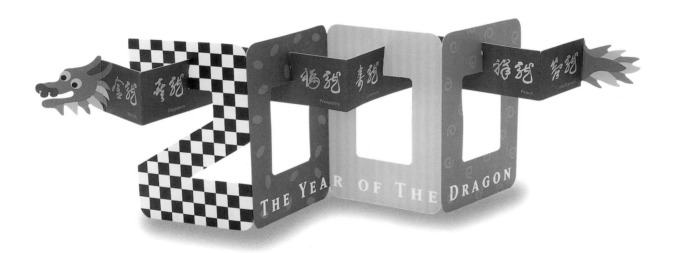

McKEE NELSON BROCHURE

Client	McKee Nelson
Design Firm	Grafik Marketing Communications
Graphic Team	Jonathan Amen / Kristin Moore / Judy Kirpich /
	Benjamin Shearn / Dean Alexander / Pat Crow
Palette	Red / Black / Blue-gray

PROJECT DESCRIPTION

McKee Nelson, specialists in tax law, needed a new capabilities brochure that set them apart from other law firms of their kind and highlighted their wealth of experience in this specialty.

PROJECT CONCEPT

According to designers, lawyers at McKee Nelson are able to see things that most law firms might not because of their extensive experience. They decided to turn this selling point into a visual presentation that would be memorable and a departure from traditional marketing materials circulated by the legal profession.

COLOR DESIGN

"We decided to visually emulate this point by using translucent red flysheets within the brochure to hide and reveal copy and images underneath," explains Jonathan Amen. So, while superficially, the brochure looks like many others from its conventional blue-gray cover, once inside, shocking red flysheets greet the reader. Once these flysheets are turned, they reveal more to the image underneath than was originally visible to the eye.

This visual trick heightens interest in the brochure and visually demonstrates the point that McKee Nelson can indeed see things that its competition might miss.

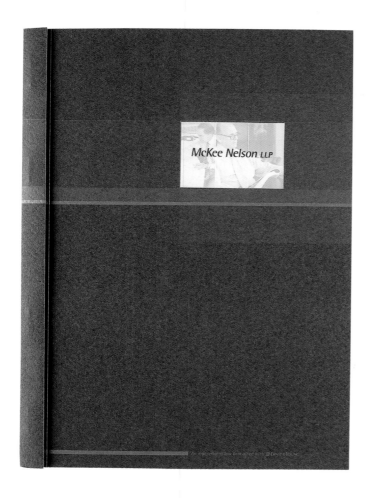

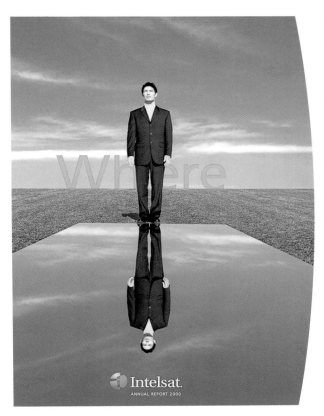

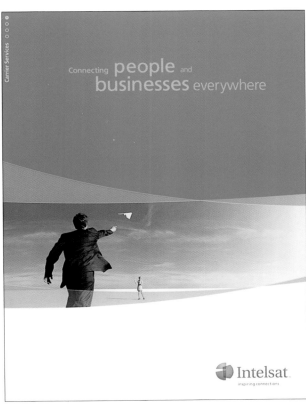

INTELSAT 2000 ANNUAL REPORT AND SERVICE FOLDERS

Intelsat	Client
Addison	Design Firm
Richard Colbourne	Art Director
Nicholas Zentner	Designer
Hannes Schmid	Photographer
Blue / Light Blue / Green / Light Green / Teal	Color Palette

PROJECT DESCRIPTION

Intelsat, a communications company, needed an annual report and series of folders representing its various divisions to reflect the brand identity.

PROJECT CONCEPT

Designers fully integrated the brand identity into each piece through photography and by changing the prominence of the colors in the basic palette.

COLOR DESIGN

In terms of the annual report, the photography showed vast blue sky and endless green grass intersecting to create a surreal landscape. Similarly, throughout the report, fields of pure blue, green, and teal intersect and overlap—reinforcing Intelsat's identity as warm, friendly, and dynamic.

The service folders work off the same landscape theme and use the same color palette. However, designers changed the focus of the primary and secondary colors when creating each of the four folders, so that each looks startlingly different—yet the same. Each works off the same color palette, but they are visually distinctive, while still remaining true to the overall brand identity.

BROWN JORDAN CATALOG, PRESS KIT, AND MARKETING MATERIAL

Client	Brown Jordan
Design Firm	5D Studio
Art Director	Jane Kobayashi
Designer	Jane Kobayashi
Palette	Silver

PROJECT DESCRIPTION

Brown Jordan, manufacturer of outdoor furniture, was introducing a new category of furniture—stainless steel—and needed a high-end catalog that would provide the entry into this market.

PROJECT CONCEPT

"We designed the catalog to highlight stainless [steel] by using metallic silver," says Jane Kobayashi. The trick was that Kobayashi didn't just use silver as an accent color, but also as the background to four-color images printed on clear polyester to carry the stainless steel theme throughout the catalog and all the marketing materials.

COLOR DESIGN

The catalog's cover and divider pages are printed with four-color images on transparent polyester. The pages underneath have metallic silver gradations, which become the background for the polyester images. The facing pages to the dividers feature silver halftones that work with the polyester divider page when it is turned and laid on top.

Similar techniques are also carried through the press kit folder, advertising campaign, and other marketing materials.

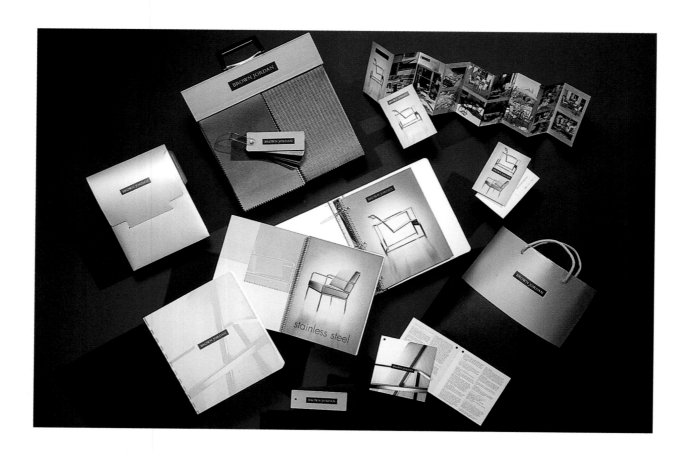

NO REASON PARTY INVITATION

Sue and Ralph Stern	Client
IE Design	Design Firm
Marcie Carson	Art Director
Marcie Carson / Amy Klass	Designers
Lime Green	Palette

PROJECT DESCRIPTION

Ever want to throw a party for absolutely no reason at all? That's exactly what these party givers wanted to do and needed an invitation that drove home that this was a "No Reason Party" invitation.

PROJECT CONCEPT

"This party invitation quickly turned into a poster, clearly stating that there is no theme or reason for this party at all," says Marcie Carson. Designers chose a bright lime green for the palette so that this invitation would not be confused with any other cause for celebration—not St. Patrick's Day green, Christmas green, or the pastels of spring. Yet, still the color choice appears festive and fun.

COLOR DESIGN

The poster folds down to an 8-inch (20-centimeter) square envelope and was printed in four-color process plus one match color. The backside and the reply card were printed in one color.

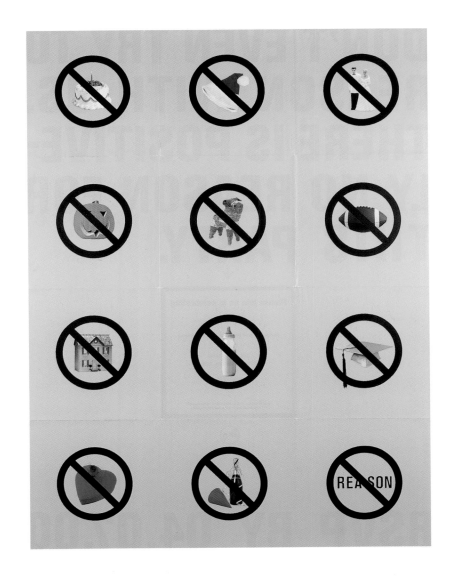

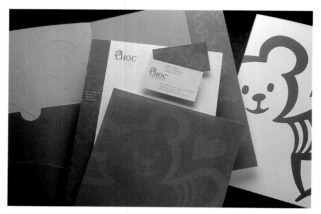

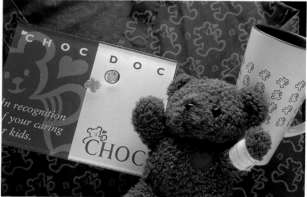

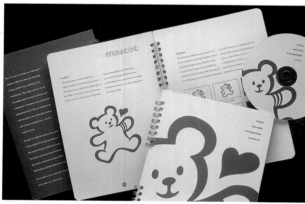

CHOC IDENTITY PROGRAM

Client	Children's Hospital of Orange County (CHOC)
Design Firm	Hornall Anderson Design Works
Art Directors	Jack Anderson / Lisa Cerveny / Debra McCloskey
Designers	Jana Nishi / Jana Esser / Steffanie Lorig / Gretchen Cook / Darlin Gray
Illustrators	Gretchen Cook / Jana Esser
Palette	Blue / Raspberry

PROJECT DESCRIPTION

The Children's Hospital of Orange County California needed materials that spoke to parents and appealed to children. Developing creative materials with the right balance was the job assigned to Hornall Anderson Design Works.

PROJECT CONCEPT

Designers created a bear mascot for CHOC and colorized him in blue because the color is inherently thought to be clean, calm, and sterile (yet not as sterile as hospital white). This blue was also warm and friendly.

COLOR DESIGN

With blue as the primary focus, designers lent the identity an accent color—raspberry, which they used to color the bear's heart. They chose the softer shade of raspberry— more of a pinkish-red—over true red, which is traditionally used for hearts because designers felt it communicated a nurturing, safe environment and would be more appealing to children than bold red.

HOLDEN COLOR INC. BROCHURES

Holden Color Inc.	Client
Barbara Brown Marketing & Design	Design Firm
Barbara Brown	Art Director
Barbara Brown / Jon Leslie	Designers
Z Studios	Photographer
Metallic Gold / Silver / Cyan / Red / Yellow	Palette

PROJECT DESCRIPTION

"When Barbara Brown Marketing & Design was given the opportunity to create a direct mail program for a large printer, we knew we might be pioneering a new way of printing," says Barbara Brown.

PROJECT CONCEPT

Instead of using regular cyan, magenta, yellow, and black inks, the designers used the metallic equivalents. "The result is a unique, complex palette full of depth and almost three-dimensional effects that provides an antique tone complementing the brochures' melodramatic, silver screen theme," states Brown.

COLOR DESIGN

One challenge to using this technique of replacing the traditional four-color process inks with their metallic equivalents meant that designers were not able to obtain a true proof before the matchprint.

To capture the movie theme, designers placed die-cuts on the cover of each brochure to mimic the look of a film strip that reveal just enough of the images below to pique reader's interest and get them to open the brochure.

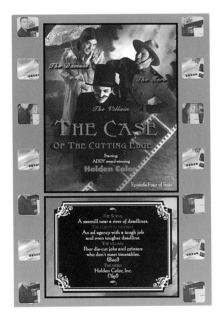

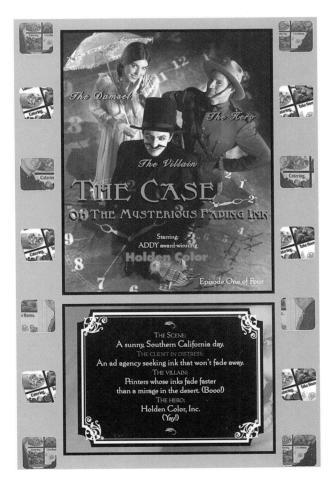

"ALL SIDES CONSIDERED" BOX SHOW

Client	Grand Rapids Public Art Museum
Design Firm	Palazzolo Design Studio
Art Director	Gregg Palazzolo
Designer	Mark Siciliano
Palette	Yellow / Purple / Black / Green / Orange

PROJECT DESCRIPTION
To promote a box show where area artists created all boxes, the Grand Rapids Public Art Museum tapped Palazzolo Design Studio for ideas.

PROJECT CONCEPT
Playing off the title of the public broadcasting program, "All Things Considered," Palazzolo Design Studio developed a box with the theme, "All Sides Considered," to promote the event. "Highlighting a primary palette on different sides of the three-dimensional illustrated boxes conceptually relates to the show," says Gregg Palazzolo.

COLOR DESIGN
The color palette is striking, eye-catching, fresh, and contemporary, which seems to make the geometric shapes stand out even more than they ordinarily would. "Having a strong field of yellow in the background only gave more emphasis on the box itself," adds Palazzolo.

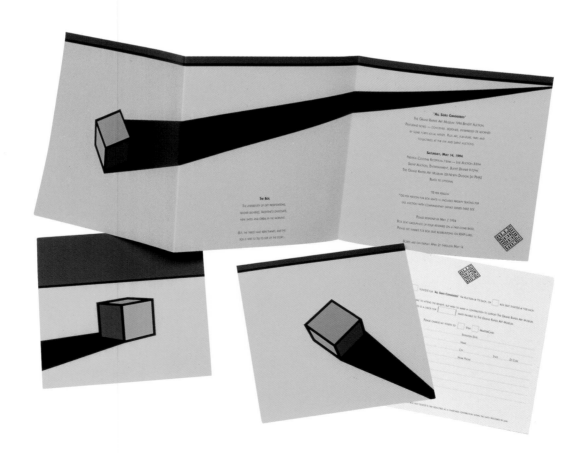

TO HAVE AND TO HOLD BRIDE AD

Lunar Design	Client
Lunar Design	Design Firm
Kristen Bailey	Art Director
Florence Bautista	Designer
Sam Yocum	Photographer
Pink	Palette

PROJECT DESCRIPTION

Lunar Design needed a self-promotional ad to appear in key graphic design publications including *ID* magazine, *Design Report* from Germany, and *Axis* from Japan. No ordinary ad would do. "Lunar wanted its ad to stand apart from the typical product-design magazine ads, which tend to feature contextless images of products," says Kristen Bailey.

PROJECT CONCEPT

Designers created the ad by selecting type and designing the layout to be reminiscent of a wedding invitation. "The pinkness of the bride ad communicates not only to the target audience—we designed this product for a nonbusiness user—but shows the personalization aspects of the product," says Bailey.

COLOR DESIGN

Using a palette of pink, pink, and more pink, according to Bailey, the ad stands out. "Overall, the ad visually and subtly conveys Lunar's ability to turn people's needs into beautiful and functional products."

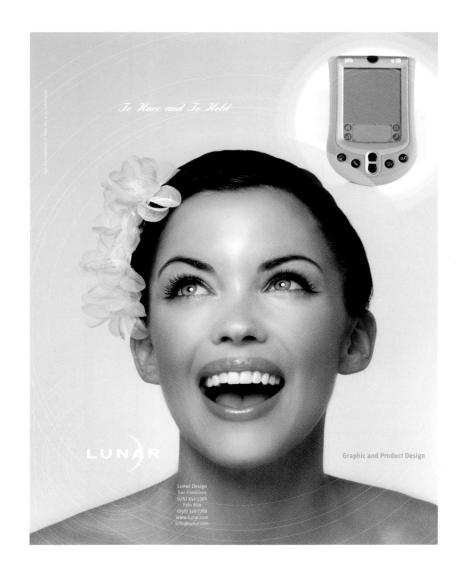

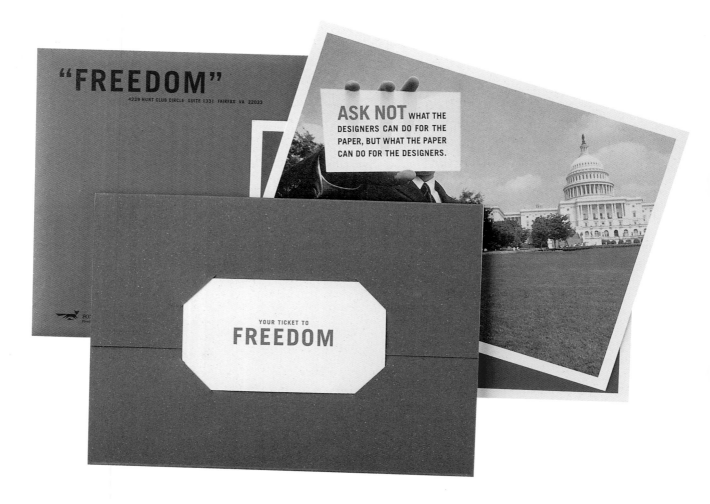

FREEDOM OF DC PARTY INVITATION

Client	Fox River Paper Company
Design Firm	Mek-Aroonreung / Lefebure
Art Directors	Pum Mek-Aroonreung / Jake Lefebure
Designers	Pum Mek-Aroonreung / Jake Lefebure
Copywriter	Steve Smith
Photographer	John Consoli
Palette	Red / White / Blue

PROJECT DESCRIPTION

Fox River Paper Company was hosting a party for Washington, D.C.–area designers and needed a party invitation that would generate a turnout for the event that kicked off at 9:00 P.M.

PROJECT CONCEPT

"The freedom concept took historic quotes and used them in the invitation for designers to come to the paper company party," says Jake Lefebure. "We selected the [Fox River] Sparkles paper to create a retro look and feel. Also, the red envelope, blue wrap, and white mini ticket make the piece fit together by reinforcing the freedom theme."

COLOR DESIGN

Designers heavily saturated the CMYK images to draw out the sparkles in the paper stock. "The muted tones and oversaturated color photos make the piece have a unique look and feel," adds Lefebure.

SMPV / SSPM LOGOTYPE

Swiss Musicpedagogic Association (SMPV) — Client
Niklaus Troxler Design — Design Firm
Erich Brechbühl — Art Director
Erich Brechbühl — Designer
Green / Rhodamine Red — Palette

PROJECT DESCRIPTION
The assignment: create a logo for the Swiss Musicpedagogic Association.

PROJECT CONCEPT
Erich Brechbühl tackled the job with two colors—a vibrant green and hot pink—and only used the acronym from the client's name—SMPV/SSPM.

COLOR DESIGN
He colored the letters, set in the typeface Globus, in each of the two hues of the palette and seemingly sliced the letters apart and interlinked them. Thanks to the expert use of color and placement, the finished logotype actually seems to show the vibration of music, which is what the association is all about.

Consumer Reaction to Color

by Leatrice Eiseman

Word-association studies that ask respondents for their reactions to color often show a marked similarity across the population. The dominant colors in the following list will generally elicit similar responses. These colors and consumer responses are taken in part from *The Pantone Guide to Communicating with Color*, published by Grafix Press. Note that for most colors, the positive responses are far more prevalent that those that might be thought of as negtive.

DOMINANT COLORS AND RESPONSES

Bright Red:
Exciting, energizing, sexy, hot, dynamic, stimulating, provocative, dramatic, aggressive, powerful

Light Pink:
Romantic, soft, sweet, tender, cute, babyish, delicate

Burgundy:
Rich, elegant, refined, tasty, expensive, mature

Fuchsia:
Bright, exciting, fun, hot, energetic, sensual

Orange:
Fun, whimsical, childlike, happy, glowing, vital, sunset, harvest, hot, juicy, tangy, energizing, gregarious, friendly, loud

Bright Yellow:
Enlightening, sunshine, cheerful, friendly, hot, luminous, energetic

Greenish Yellow:
Lemony, tart, fruity, acidic

Beige:
Classic, sandy, earthy, neutral, soft, warm, bland

Coffee or Chocolate:
Rich, delicious

Deep Plum:
Expensive, regal, classic, powerful, elegant

Lavender:
Nostalgic, delicate, sweet, scented, floral, sweet-tasting

Orchid:
Exotic, flowers, fragrant, tropical

Sky Blue:
Calming, cool, heavenly, constant, faithful, true, dependable, happy, restful, tranquil

Bright Blue:
Electric, energetic, vibrant, flags, stirring, happy, dramatic

Navy:
Credible, authoritative, basic, classic, conservative, strong, dependable, traditional, uniforms, service, nautical, confident, professional, serene, quiet

Aqua:
Cool, fresh, liquid, ocean, refreshing, healing

Dark Green:
Nature, trustworthy, refreshing, cool, restful, stately, forest, quiet, woodsy, traditional, money

Bright Yellow-Green:
Artsy, sharp, bold, gaudy, trendy, tacky, slimy, sickening

Black:
Powerful, elegant, mysterious, heavy, basic, bold, classic, strong, expensive, magical, nighttime, invulnerable, prestigious, sober

Taupe:
Classic, neutral, practical, timeless, quality, basic

Gold:
Warm, opulent, expensive, radiant, valuable, prestigious

PRECIS BROCHURE

Client	Millward Brown
Design Firm	Lewis Moberly
Art Director	Mary Lewis
Designers	David Jones / Bryan Clark
Illustrators	Bryan Clark / Steven Sayers
Palette	Red / Yellow

PROJECT DESCRIPTION

Client Millward Brown needed a brochure to market Precis, a software brand in the media analysis sector that explains its services in simple terms.

PROJECT CONCEPT

"Color is used in a literal way to change perspective and to explain the key attributes, services, and benefits that Precis can offer," says Mary Lewis. Red, aside from being an attention-getting color that communicates vibrancy and strength, is used here to create visual trickery that helps keep reader interest high.

COLOR DESIGN

The red brochure includes interleaved color film that renders part of each printed line illustration invisible until the film page is turned. "The revealed remainder of the illustration changes the viewer's perception of what he thought he was seeing," says Lewis.

The red film demands attention and the yellow pages signal caution—you can't always trust what you see.

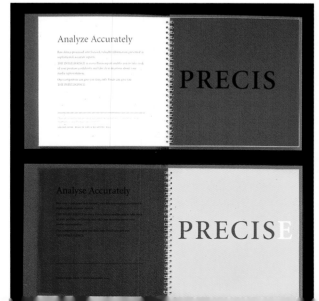

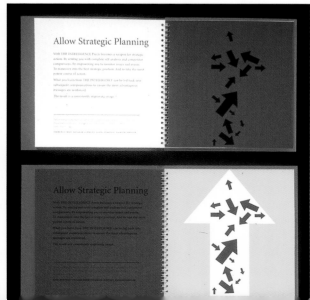

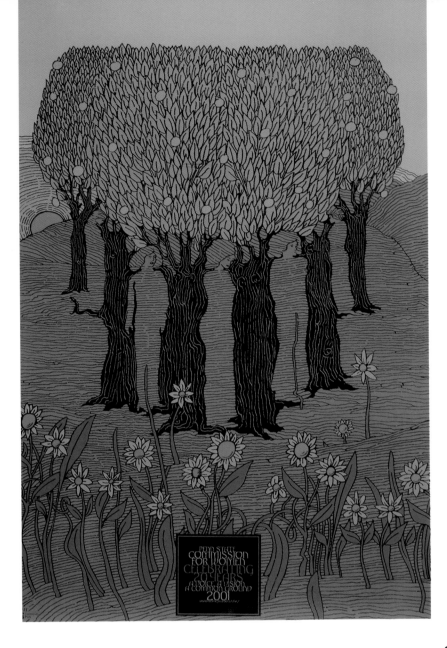

COMMISSION FOR WOMEN 20 YEARS POSTER

Pennsylvania State University Commission for Women	Client
Sommese Design	Design Firm
Kristin Sommese	Designer
Lanny Sommese	Illustrator
Hot Pink / Orange / Green / Purple / Blue / Black	Palette

PROJECT DESCRIPTION

Penn State's Commission for Women was celebrating its twentieth anniversary and wanted Sommese Design to create a poster to commemorate the event.

PROJECT CONCEPT

In an effort to show the organization's growth over twenty years, Sommese Design created a simple illustration of flowers and trees reaching for the sky but, although these images are what we might expect to see, the color palette is not. Color placement is unexpected; the sky is green and the grass is blue.

COLOR DESIGN

Originally, a bright red was specified to appear where hot pink and orange is currently. "I had intended for the flower centers and the sun to be connected visually through color that was bright and vibrating," says Kristin Sommese, who reviewed the proof and didn't think the colors were as intense as they needed to be. "I determined that if we printed a fluorescent spot color instead of the red generated through a full-color separation, I would get the intensity I was looking for. This was something I could never have considered but I liked the quirkiness of it in relation to the other colors."

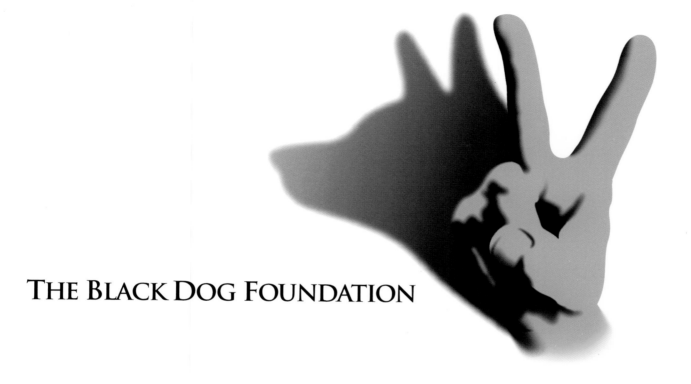

THE BLACK DOG FOUNDATION

THE BLACK DOG FOUNDATION LOGO

Client	The Black Dog Foundation
Design Firm	Cato Purnell Partners Pty. Limited
Palette	Red Orange / Black

PROJECT DESCRIPTION

The Black Dog Foundation, an organization that counsels for depression, tapped Cato Purnell Partners for a logo that avoided a clinical appearance, yet spoke to the organization's mission.

PROJECT CONCEPT

The symbol for the foundation took its inspiration from Winston Churchill on two counts. First, it incorporates his *V* for victory salute as well as the fact that he always likened depression, from which he suffered, to a black dog constantly lurking.

COLOR DESIGN

To portray these complex messages visually, designers incorporated the victory salute into a finger-puppet shadow display where the salute is prominent in the foreground, while a dog appears in the shadow... constantly lurking. Black was the obvious choice for the dog's shadow, which communicates depression and lack of warmth. More important, by using this technique, designers sidestepped the obvious black dog motifs of Labrador retrievers and other black breeds, which are now commonplace on logos ranging from beer to clothing.

AURORA / LIGHT FANTASTIC

Darling Harbour Authority	Client
Cato Purnell Partners Pty. Limited	Design Firm
Primary colors	Palette

PROJECT DESCRIPTION

Australia's Darling Harbour Authority retained Cato Purnell Partners to promote its summer "light festivals" in a nighttime party environment.

PROJECT CONCEPT

The concept was inspired by the "painting with light" technique that is used during the light festivals. However, Cato Purnell Partners recorded this light show on film and then transformed these nighttime images into abstract pieces of art.

COLOR DESIGN

"The film images were translated into raw primary colors to give an abstract interpretation of the intent of the festivals," say the designers. The result is almost like a negative piece of film, only here, the colors are vibrant and designers exchange them and mix and match them at will. By using a primary color palette, they achieve an energy against the dark background that is closely akin to the show of light on night sky, despite the obvious limitations of being reproduced as ink on paper.

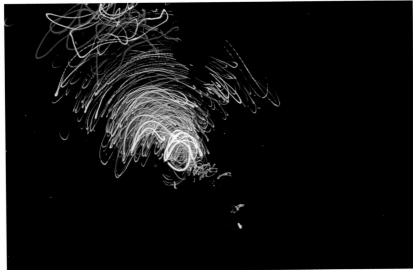

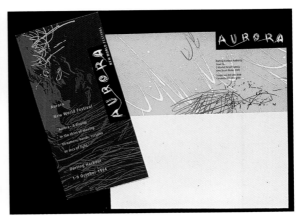

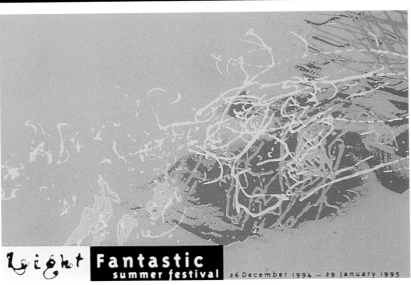

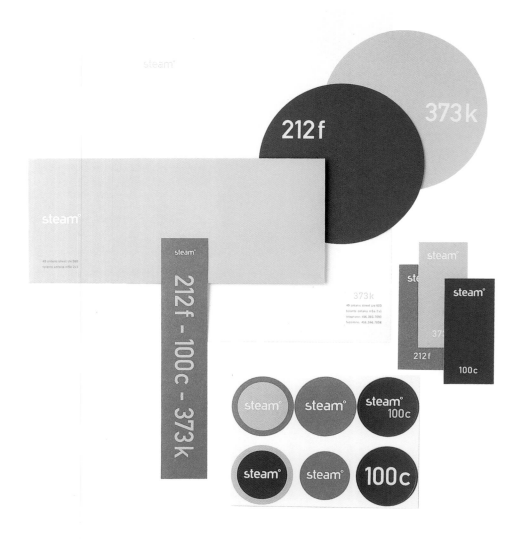

STEAM FILMS STATIONERY SYSTEM

Client	Steam Films
Design Firm	Blok Design Inc.
Art Director	Vanessa Eckstein
Designers	Vanessa Eckstein / Frances Chen / Stephanie Yung
Palette	Dark Blue / Medium Blue / Light Blue

PROJECT DESCRIPTION

Steam Films, an innovative film company, needed a stationery system that reflected its unique creativity. Blok Design Inc. came on board to deliver the identity.

PROJECT CONCEPT

"The entire concept behind Steam was to express that unique creative moment—as if a boiling point—in which one state is transformed into another," says Vanessa Eckstein. The idea that steam is a changing thing—occurring only after water is heated—called for an equally fluid and changing identity. Hence, designers chose to use a palette based on three shades of blue—blue because of its association with water and three shades to graphically illustrate the changing state of steam.

COLOR DESIGN

"We chose three colors of blue from light to dark and three numbers that reflect that moment in three different measurements to enhance the concept," says Eckstein. "These visual elements flow in and out of the system building a dynamic of its own."

7 NETWORK IDENTITY SYSTEM

7 Network	Client
Cato Purnell Partners Pty. Limited	Design Firm
Primary Colors	Palette

PROJECT DESCRIPTION
Cato Purnell Partners developed this identity system for a television station based on the color spectrum.

PROJECT CONCEPT
When a projected band of pure light is bent through a prism into a triangle, the numeral seven emerges as a unique piece of brand typography. As a result, the color palette is derived naturally from the primary color spectrum.

COLOR DESIGN
The colors are basic—as is the client's slogan, "7. The One to Watch." The colors are also easily adapted to all mediums including the giant graphic sculpture outside the television company's corporate headquarters.

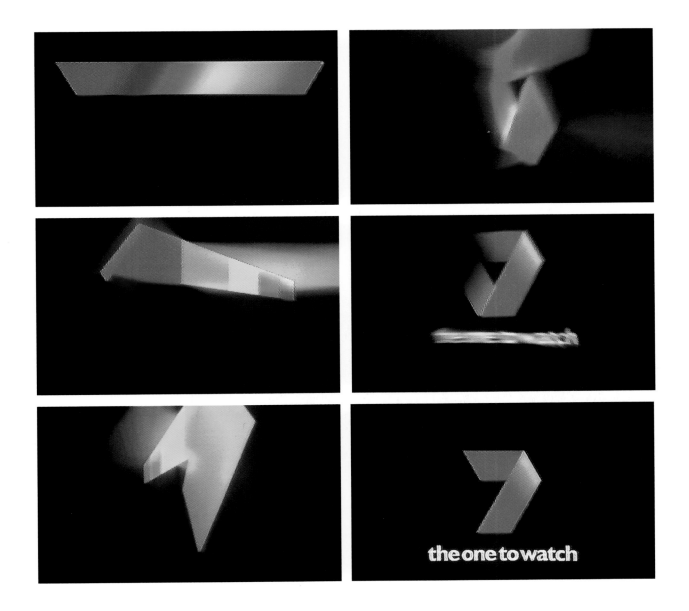

the one to watch

METROMEDIA TECHNOLOGIES CORPORATE IDENTITY SYSTEM AND CAPABILITIES FOLDER

Client	MetroMedia Technologies
Design Firm	IE Design
Art Director	Marcie Carson
Designers	Richard Maymie / Marcie Carson / Cya Nelson
Palette	Blue / Orange

PROJECT DESCRIPTION

MetroMedia Technologies is a large-format digital imaging company that uses a patented painting process to put more focus on the images and billboards that it produces. When the company needed an identity system and ancillary materials, IE Design decided to take a page from its client's services and develop a promotion that spoke to MetroMedia's special technique for getting noticed.

PROJECT CONCEPT

Designers chose to remove color and put the emphasis on the metallic silvery paper it specified for the job—Curious Metallics, Lustre Text—to give the stationery system a clean, modern look with texture, yet minimal color.

COLOR DESIGN

As a result, the system is sleek and professional, without being obtrusive. In fact, when the capabilities folder is opened, with its complex die-cut pattern of holes on the pocket, a small, orange brochure begs the question: What turns your head? The answer lies in the pocket folder. Here lie the examples of MetroMedia's work and they are eye-popping, especially alongside the blue-gray pocket folder.

Interestingly, the copy on the left of the pocket runs as follows: "Constantly surrounded by the ordinary and the mundane, people are drawn to the exceptional and the unexpected. Among the gray hues of commonplace imagery, MMT makes a vibrant impression." Indeed, that is exactly what this identity accomplishes by using a lack of color and embellishments to draw attention to what really counts.

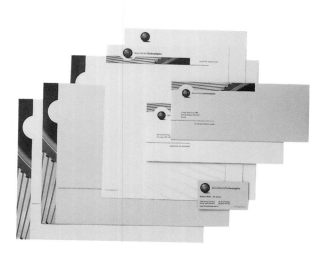

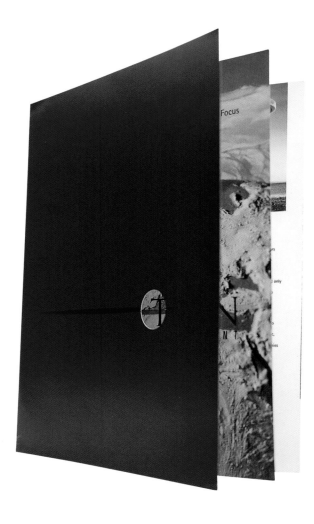

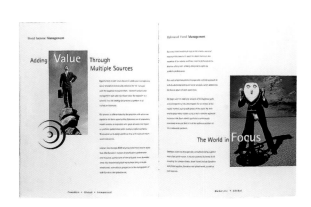

LAKETON INVESTMENT MANAGEMENT PROMOTIONAL BROCHURE

Laketon Investment Management — Client
The Works Design Communications Ltd. — Design Firm
Scott Mcfarland — Creative Director
Royal Blue / Gold — Palette

PROJECT DESCRIPTION

The Works Design Communication Ltd. was asked by Laketon Investment Management to create a promotional piece that would reflect its new expansion. The newly created workforce combined fifties conservatives with a young, thirties, up-and-coming group.

PROJECT CONCEPT

The idea for the brochure was to develop a promotional piece that would reflect experience and stability combined with creativity and freshness.

COLOR DESIGN

The brochure design revolved around a key phrase: "Laketon—bringing the world into focus." The new logo, which was the dominant cover done as a circular cutout from the underlying page, was designed to reflect an abstraction of that global view. Pushing a design-forward concept, Scott Mcfarland created an unusual inverted design in which pure color with an integrated logo is on the cover whereas photographic images and corporate name are within. He then stabilizes the inverted design with the choice of rich but traditional colors: royal blue and gold.

441-4 COLORS FOR THE PRICE OF 1

Client	Fraser Papers, Inc
Design Firm	The VIA Group
Designers	Oscar Fernandez / Andrea Kranz
Copywriters	Wendie Wulf / Kari Lowery
Production	Shelly Pomponio
Palette	Spectrum Colors

PROJECT DESCRIPTION

VIA was asked by Fraser Paper, a paper manufacturer of uncoated cover and commercial papers, to create a print piece for the Fraser Brights/Torchglow Opaque product line. The object was to increase sales and to increase awareness that colored paper was a reasonable way to create design without the expense of four-color processing.

PROJECT CONCEPT

The idea was to challenge designers on a limited budget to create dramatic and interesting impact with one color. The theme "4 colors for the price of 1," in addition to being a promotional piece, could also be used as an instruction book that showed designers a variety of ways to use colored paper in their designs.

COLOR DESIGN

Design and color were promoted as the key ingredients in communication as an alternative to the use of expensive printing techniques. Each color of paper was treated as an individual graphic work that explored the use of halftones, line art, illustrations, blurred images, hand-drawn elements, and other design options. The materials explored various design possibilities and promoted the idea of the strength and flexibility of a singe color choice. In addition, on each page there were descriptive color associations and an ongoing poetic text.

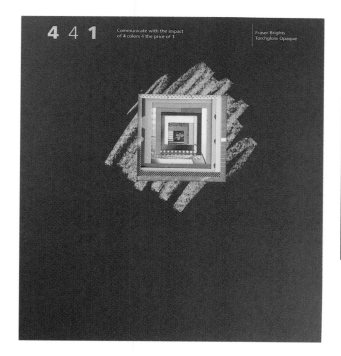

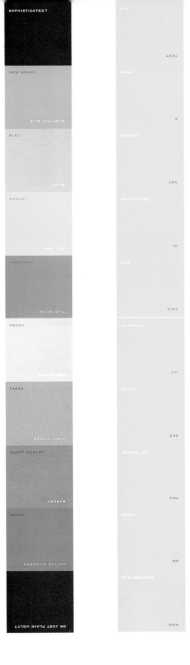

KBDA PROMOTIONAL PIECE

KBDA	Client
KBDA	Design Firm
Barbara Cooper	Creative Director
Barbara Cooper	Designer
Black / Blue / Mango / Blue-Green / Peony / Burgundy / Yellow-Green / Brown	Palette

PROJECT DESCRIPTION

The purpose of the promotional piece was to look at the difference in response between the client and the designer.

PROJECT CONCEPT

The concept behind the piece was to show awareness on the part of the designer that the client's response to color is often very different from that of the design team. The multi-colored strip shows a designer's understanding of the client's interpretation of color. The client's and the designer's color feeling is represented in each color square.

COLOR DESIGN

The color design identifies two different types of responses to individual colors. The color strip says "How do you see it" and suggests that designers and clients don't always agree on color interpretation. Not only does it portray meanings for each color, but it shows that there is more than one interpretation. It acts as an educational piece in that it describes color meanings from the more sophisticated designer's point of view.

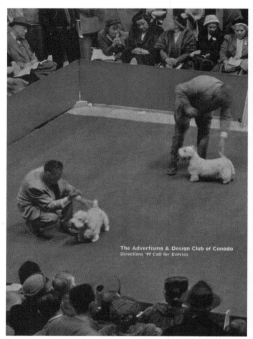

The Advertising & Design Club of Canada
Directions '99 Call for Entries

ADVERTISING AND DESIGN CLUB OF CANADA CALL FOR ENTRIES

Client	Advertising and Design Club of Canada
Design Firm	Dinnick and Howells
Designers	Sarah Dinnick / Jonathan Howells
Palette	Warm Gray / Pinks / Mint Greens / Turquoise

PROJECT DESCRIPTION

The Advertising and Design Club of Canada hired Dinnick and Howells to create an entry form and collateral materials for their annual show and awards demonstration. In addition to the entry form, Dinnick and Howells designed posters, banners, and tickets.

PROJECT CONCEPT

The show was to honor the people who represented the best of the year's creative work. Dinnick and Howells decided that they wanted to take a lighthearted approach, spoofing themselves and the design world with the entry form concept. They created a playful and amusing invitation based on a prize-winning 1950s dog show with different sizes and shapes of award-winning dogs anchoring each section of the entry form.

COLOR DESIGN

The images and colors were chosen because they stemmed directly from the 1950s. They were grained to soften the images and decrease the intensity of the color. For contrast and clarity, the explanatory section was done in warm grays and creams.

LEE POLO COLLECTION DIRECT-MAIL PROMOTION

VF Brand Solutions	Client
Fitch	Design Firm
Deb Deshetler	Senior Designer
Tammy Moore	Copywriter
Sandy Mckissick	Production
Creams / Metallic Green / Greens / Blue	Palette

PROJECT DESCRIPTION

Fitch was asked by VF Brand Solutions, a division of VF Corporation, the world's leading apparel manufacturer, to create several direct-mail packages to promote and encourage the trial of Lee Polo Collection. The target markets for the collection were distributors who could sell the product as is or decorators who could use the product for embroidery or decoration.

PROJECT CONCEPT

VF gave Fitch tremendous flexibility. Because the target audience was young and hip, Deb Deshetler and her team wanted to create a look that in itself was trend-setting and fashion-forward. Stemming from the concept of shirt decoration, they came up with the idea of using the tattoo as a theme. Although tattooing had become more mainstream, they wanted to be slightly more conservative when it came to content, so they decided to base the concept on a tribal tattoo pattern. Simple geometric cut-outs were used on the cover, and tribal designs were placed on the mailing shirt box.

COLOR DESIGN

The only chromatic colors used for the tattoo promotion were the colors of the shirts. The pieces themselves were done primarily in gray and cream. The metallic gray on the shirt box created an au currant feeling. The color of the shirts came through in the tattoo cutouts on the cover. The punch-through color created contrast, intensity, and excitement with the rest of the piece. The color of the merchandise showing through reinforced the idea of being fashion-forward and trend-savvy.

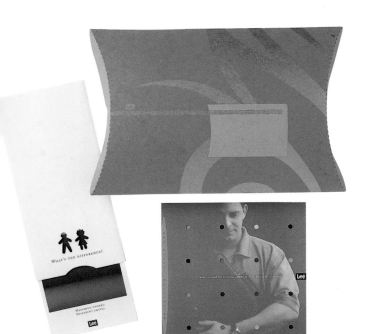

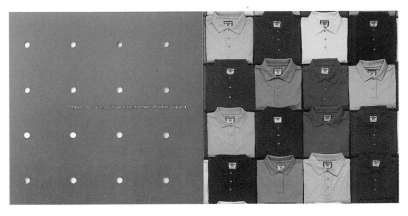

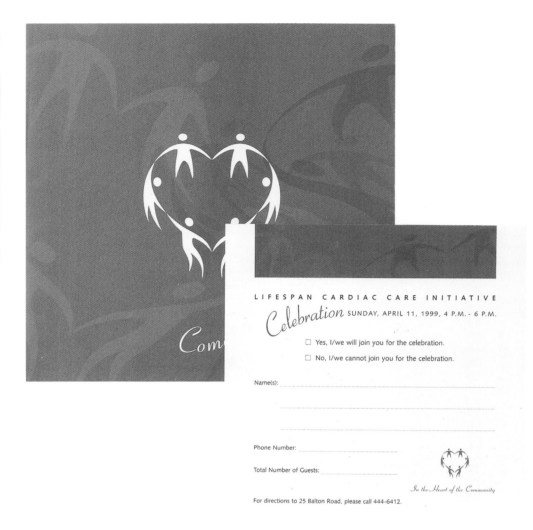

LIFESPAN CARDIAC CARE INITIATIVE

Celebration SUNDAY, APRIL 11, 1999, 4 P.M. - 6 P.M.

☐ Yes, I/we will join you for the celebration.

☐ No, I/we cannot join you for the celebration.

Name(s):

Phone Number:

Total Number of Guests:

In the Heart of the Community

For directions to 25 Balton Road, please call 444-6412.

INVITATION FOR LIFESPAN CARDIAC CARE INITIATIVE FUND-RAISER

Client	Lifespan Cardiac Care Initiative
Design Firm	Mad Creative
Designer	Michele Aucoin / Matt Castigliego (logo)
Copywriter	Lifespan
Palette	Reds / Black

PROJECT DESCRIPTION

Mad Creative was asked to create an invitation for a fund-raising event to support the purchase of automatic external defibrillators.

PROJECT CONCEPT

Although seemingly controversial for a hospital event, Mad Creative designed a red invitation. The logo, supplied by Lifespan, portrayed a circle of figures dancing in a celebratory, lighthearted fashion. They took the logo and repeatedly superimposed it in various gray tones to create an active, varied, and vital surface.

COLOR DESIGN

Although this was a hospital fund-raiser, the red of the invitation is not associated with "blood red" but, rather, a tomato-heart red in various intensities, associated with warmth.

ANNUAL REPORTS BOOK FOR CONSOLIDATED PAPER

Consolidated Paper	Client
Cahan and Associates	Design Firm
Bill Cahan	Creative Director
Bob Dinetz / Kevin Roberson	Designers
Spectrum Colors	Palette

PROJECT DESCRIPTION

Consolidated Paper hired Cahan and Associates to create a sixteen-page book that talked about annual reports to be used as a promotional piece.

PROJECT CONCEPT

Cahan and Associates, renowned for their annual reports, took the opportunity to create an interesting and varied commentary on different aspects of annual report presentation. They created the book with physical weight and substance (in the shape of a brick) in a mere 522 pages (not the sixteen intended). Various chapters commented on copy, typography, design, and color.

COLOR DESIGN

The many colors used in Consolidated Paper's book were intentionally untraditional. Instead of traditional corporate blue, green was used in the dividers for each chapter. Bright, intense colors were used throughout the book as background pages. Several chapters talk about the use of color; for example, a chapter focuses on corporate blue and compares Ford, IBM, and other companies.

ANNUAL REPORT FOR MOLECULAR BIOSYSTEMS

Client	Molecular Biosystems
Design Firm	Cahan and Associates
Creative Director	Bill Cahan
Designer	Kevin Roberson
Palette	Warm Pinks / Magenta / Cyan

PROJECT DESCRIPTION

Molecular Biosystems (MB)asked Cahan and Associates to create an annual report highlighting Optison, an advanced-generation ultrasound contrast agent. Developed and manufactured by MB, the low-dose agent offers doctors a clearer ultrasound image by increasing contrast.

PROJECT CONCEPT

Bill Cahan's conceptual strategy visually portrayed the difference between the low-contrast, fuzzy image provided by regular agents and the high contrast, clear image that the contrast agent provides. By creating fuzzy images that could be interpreted in several ways, Cahan shows the importance of the dye. Using a play on words and images he implies, "Let's show what the world would be without contrast."

COLOR DESIGN

The color design stemmed from a picture of color microspheres given to Cahan. Pink was highlighted because it was a very human, fleshy color, and its pastel nature enhanced the fuzziness of the image, making it harder to decipher. In an image in which clarity had been resolved using the drug, a very intense magenta was used along with a cyan background to show contrast.

Valentis	Client
Cahan and Associates	Design Firm
Bill Cahan	Creative Director
Sharrie Brooks	Designer
Pink / Rust / Lime Green / Black / Reds / Muted Yellow	Palette

PROJECT DESCRIPTION

Valentis, a high-tech medical firm involved in the development of a broad array of products, technologies, and intellectual property for the delivery of biopharmaceuticals, asked Cahan and Associates to create an annual report.

PROJECT CONCEPT

Cahan and Associates took what was a very abstract medical concept in research stages and tried to create an abstract visual concept. Influenced by art and modern and postmodern architectural theory, they were able to create a visual image. Over the past few years, the medical concept has evolved into products being clinically tested so the design has become more concrete. The arrows on the cover of the 2000 annual report suggest the forward movement into clinical trials of the products.

COLOR DESIGN

The designers at Cahan worked with abstract, fine arts-based color palettes and intentionally added the pink, which is somewhat unusual and jarring, to support the idea of a new and revolutionary concept. The color placement is also used to support the idea of progression.

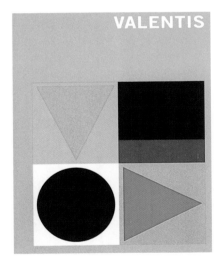

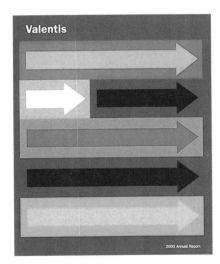

IV IL-2 gene medicine efficacy in an animal tumor model

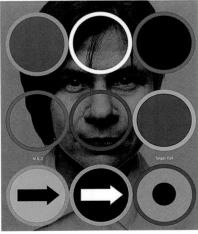

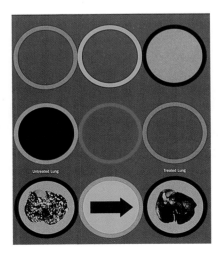

LOGO AND IDENTITY PROGRAM FOR GOFISH.COM

Client	gofish.com
Design Firm	The VIA Group
Creative Director	Steve LaChance
Art Director	David Puelle
Lead Designer	Chris Cote
· Designers	Chris Jones / Steve LaChance
Palette	Orange / Blue / Gray

PROJECT DESCRIPTION
Gofish.com, an online business-to-business exchange company for the seafood industry, asked The VIA Group to create a logo.

PROJECT CONCEPT
The logo concept was the idea that everything that gofish.com did was not only a transaction, but an actual interaction between buyer and seller. The simple fish graphic is surrounded by two interlocked color fields.

COLOR DESIGN
VIA used color to express this relationship. Orange represented the buyer, blue represented the seller, and the common ground where the exchange takes place is a mixed gray. It is the sum of two color complements and represents the total visual spectrum—and also represents the mixing of buyer and seller.

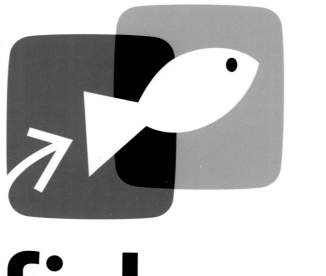

gofish.com
cast a wider net

CATALOG FOR INTERNATIONAL CERTIFICATE PROGRAM FOR NEW MEDIA

Rhode Island School of Design Division of Continuing Education and the Fraunhofer Center for Client
Research in Computer Graphics and Technische Universitat Darmstadt in Germany

Migliori Design Design Firm

Marianne Migliori Creative Director

Orange / Blue Palette

PROJECT DESCRIPTION

Marianne Migliori was asked by Rhode Island School of Design Division of Continuing Education and the Fraunhofer Center for Research in Computer Graphics and Technische Universitat Darmstadt in Germany to design a catalog for their joint program, an International Certificate Program for New Media.

PROJECT CONCEPT

Because the program is geared to people who wish to "develop, design and implement New Media projects," Migliori chose to create a cover image that would emphasize the relationship between technology and art. She decided to use the pixel, the basis of visual technology in an artistic—almost pointillist—direction. She used an image of a globe from student work to represent the scope of the program.

COLOR DESIGN

The pixilated color was highlighted with superimposed squares and orange type. Because they are a warm combination, orange and blue were drawn from the pixilated image of the globe. The interior pages were done in duotone blue. Even the photographic images were done in blues to avoid any reference to color or race. RISD had wanted to make a bright, colorful statement to create drama and contrast. This excitement and energy was achieved by using high-intensity color on the back and front inside covers. Even a redhead is shown in full color to enhance the mood.

CHRISTMAS CD

Client	Albertsen and Hvidt
Design Firm	re:public
Creative Directors	Athena Windelev / Morton Windelev
Art Director	Athena Windelev
Palette	Orange

PROJECT DESCRIPTION
Re:public was asked by Albertsen and Hvidt, a young consultancy, to create packaging for their Christmas card gift.

PROJECT CONCEPT
The main idea behind the project was to create a new and refreshing image for the consultancy. To create an edge for the piece, the image on the cover is a lamp created by designer Ann Jacobsen, done in a warm orange color.

COLOR DESIGN
The orange is used for aesthetic purposes and sends the powerful message of "a controllable wild." It is interesting that although it is Christmas, orange is used instead of red.

BOBLBEE BACKPACK CAMPAIGN

Act AB	Client
2GD	Design Firm
Jan Nielson / Ole Lung	Creative Directors
Silver Gray / Orange Skin Tones	Palette

PROJECT DESCRIPTION

Act AB, a Swedish company, asked 2GD to create a strategy for the launching of Boblbee, a unique backpack.

PROJECT CONCEPT

In order to appeal to young urbanites, 2GD composed a strategy which incorporated images of city life for the launch of the Boblbee urban backpack.

COLOR DESIGN

The color scheme for the campaign is dynamic, smooth, and metallic to reflect the identity. The logo remains achromatic to contrast with the intensity of the figures and the silver background color.

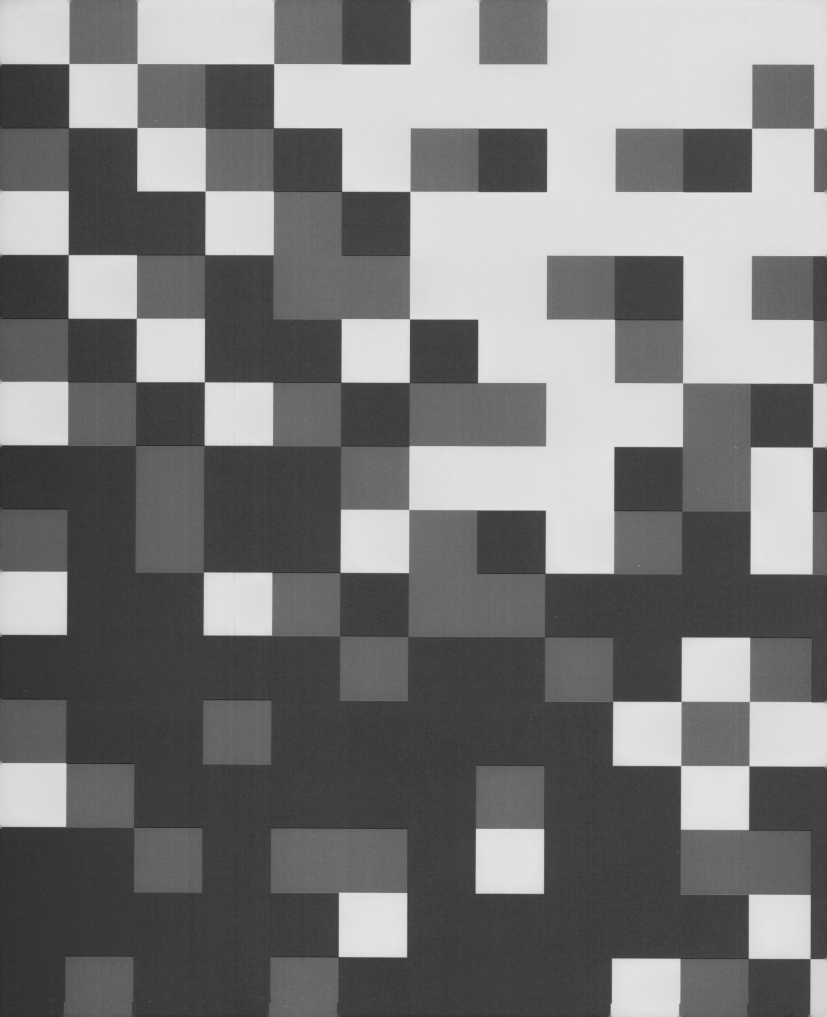

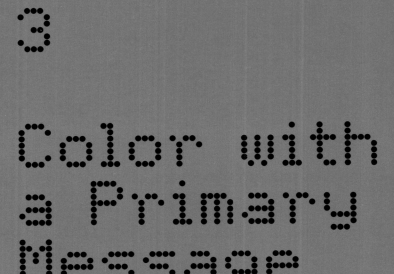

3
Color with a Primary Message

The bold, graphic appearance of color used to convey a primary message clarifies, enhances, and defines images to get the point across fast. More often than not, these strong color choices are easily readable and identifiable and seem to be based on experiential knowledge. Although not as sophisticated or unique, these colors that we view quite frequently generate an immediate response.

Often these colors imply a functional message—as red, green, or yellow traffic lights and signs—or have an everyday, natural association—such as grass green or sky blue. In his promotional piece, 110 Years of Ljubljana Waterworks, Edi Berk used blue to identify and create a common association that people make with water. Green was also used as identification with land.

Primary message color can also be a color affiliated with a strong brand identity. Large corporations such as Coca-Cola and Dunkin' Donuts use red and pink respectively to identify themselves and other products under their domain. The use of a corporate color will give the product a stronger market presence. This was the case for the Levi's invitation—when they talk about true blue, they're talking about the Levi's brand.

In addition to specific corporations, types of industries, groups of people, or age groups can be identified through certain color choices. Primary colors or pastels are used quite successfully when it comes to children's and related industries. Metzler and Associates used primary colors in a logo for Smobey's—a manufacturer of children's toys—to create an association with children.

Primary message color can also be used as a reinforcement of an idea. In the member's journal of the Toronto Art Gallery, designed by Dinnick and Howells, background color is taken directly from the central image on the cover or the artistic period of the artwork. It reinforces the concept and theme of the issue. Primary color can be used to reinforce the strength or meaning of a piece. In the design of the B/Stop Poster by KROG, the familiar red is a universal symbol to halt. Due to cultural experience, these responses are almost innate and, thus, influence our attitude toward them.

Primary message color is the color that "beats its chest." This "here I am and this is my point" type of color is the color of choice to sell merchandise, create a direct link, or make a point clearly and expediently.

UCLA IN LA

Client	UCLA—Vice Chancellor/External Affairs
Design Firm	Gregory Thomas Associates
Art Director	Gregory Thomas
Designers	Gregory Thomas / Julie Chan / David LaCava
Illustrator	Julie Chan
Palette	Red / Blue / Yellow / Orange / Purple / Green

PROJECT DESCRIPTION

UCLA plays an incredibly influential role in Los Angeles County. "Despite its many projects ranging from health care to K–12 education, the university was concerned that its message was not being distributed to its many constituents," says Gregory Thomas of the map/brochure project that was to be titled "UCLA in LA."

PROJECT CONCEPT

To drive home the point that UCLA is accessible throughout the county, designers decided to create a snapshot of UCLA in LA. Using bright colors and geometric shapes to define UCLA's involvement, the poster met all the objectives and more. Color was the prime instrument in illustrating the diverse areas of involvement.

COLOR DESIGN

Color-coding has long been a way to cleanly organize lots of information for easy reference. Here, traditional color-coding goes one step further. A blue cross is used to denote health services programs and their locations and a red house stands for K–12 educational programs, all of which makes for easy reference. But more importantly, when all these symbols are scattered across the map, the color symbols reinforce the message that UCLA is not only in LA, it *is* LA.

DUTCH GRAPHIC DESIGN: 1918–1945 EXHIBITION POSTER

Massachusetts College of Art—Boston	Client
Elizabeth Resnick Design	Design Firm
Elizabeth Resnick	Art Director
Elizabeth Resnick	Designer
Elizabeth Resnick	Photographer
Red / Yellow / Blue	Palette

PROJECT DESCRIPTION

Elizabeth Resnick's firm was retained to create a poster to promote an exhibition of Dutch graphic design during the time period between World War I and World War II.

PROJECT CONCEPT

The idea was to develop a poster with a contemporary flair to promote a period of graphic design that was popular more than sixty years ago.

COLOR DESIGN

Resnick used colors popular with the De Stijl aesthetic—a palette of the primaries and the clean lines of Futura—to emphasize the period between 1917 and 1939, which is the same period in which the De Stijl Movement was in full gear. De Stijl, which originated among a group of Dutch artists in Amsterdam, is characterized by its clean type, primary colors, and geometric images.

EDUCATING ARTISTS FOR A MULTICULTURAL WORLD POSTER

Client Professional Arts Consortium
Design Firm Elizabeth Resnick Design
Art Director Elizabeth Resnick
Designer Elizabeth Resnick
Palette Red / Yellow / Orange / Blue / Green / Purple

PROJECT DESCRIPTION

The Professional Arts Consortium, which offers educational programming for a consortium of six area colleges dedicated to the visual and performing arts, needed a poster to announce an upcoming seminar.

PROJECT CONCEPT

The seminar, which discussed the benefits of fostering racial and cultural diversity in curricula and on campuses, needed to communicate that diversity is a good thing— something to be promoted.

COLOR DESIGN

Elizabeth Resnick opted to use a rainbow palette as a metaphor for diversity as she built the design. Using all the colors of the rainbow—red, yellow, orange, blue, green, and purple—as a process job, she aptly communicated both visually and metaphorically that racial and cultural diversity can be beautiful.

CONQUEROR—COLOUR SOLUTIONS

Arjo Wiggins	Client
HGV	Design Firm
Pierre Vermeir	Art Director
Damian Nowell / Christian Eves	Designers
Black / Cyan / Magenta / Yellow	Palette

PROJECT DESCRIPTION

Arjo Wiggins, a manufacturer of fine printing papers, needed packaging that would communicate that its new ultrawhite paper, Conqueror—Colour Solutions—was ideal for printing with a color laser printer, inkjet printer, and color photocopier.

PROJECT CONCEPT

The triangular icon that is used universally to signify toner appears traditionally in black. Designers at HGV decided it was time to infuse some color into this familiar icon to symbolize that their client's product can be used in laser printers, inkjets, and photocopiers.

COLOR DESIGN

Designers colored the icon with a palette that comprises four-color process printing—black, cyan, magenta, and yellow (with two secondary hues). The result is a clean package with an unmistakable message.

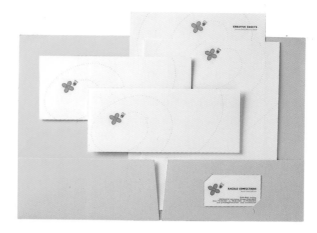

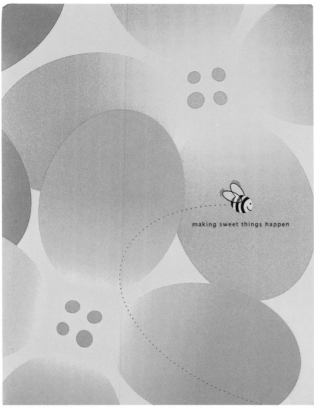

making sweet things happen

RAGOLD CONFECTIONS STATIONERY PROGRAM

Client	Ragold Confections Inc.
Design Firm	JOED Design Inc.
Art Director	Edward Rebek
Designer	Edward Rebek
Palette	Black / Yellow / Orange / Blue / Purple / Green

PROJECT DESCRIPTION

Ragold Confections Inc., a candy manufacturer that also imports and exports products, manufactures private-label goods, and develops new products, needed an identity system that united the company while distinguishing the different divisions.

PROJECT CONCEPT

JOED Design Inc. developed the bee and flower design, along with the tagline "making sweet things happen" to suggest Ragold Confections' involvement in the process. Rather than creating different color-coded folders for each division, the design team took a more subtle approach.

COLOR DESIGN

Different colored flowers were used to represent each of the company's four divisions. The pocket folder is the only piece that incorporates all the colors in one place—which cut expenses tremendously. Business cards and the folder were printed on the same form as well, resulting in an additional savings. Likewise, the letterhead and envelopes were printed on the same form.

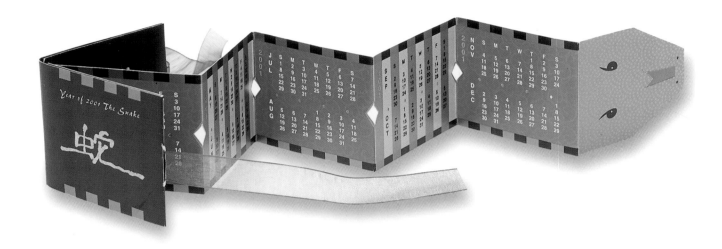

2001 YEAR OF THE SNAKE CARD/CALENDAR

Team 7 International	Client
Julia Tam Design	Design Firm
Julia Chong Tam	Art Director
Julia Chong Tam	Designer
Julia Chong Tam	Illustrator
Purple / Black / Gold / Red	Palette

PROJECT DESCRIPTION

Julia Tam Design, which regularly designs the Chinese New Year cards for Team 7 International, strives to keep the look fresh year after year—and maintain a traditional Chinese motif, while creating a card that will be memorable and elegant. When the time came to design the Year of the Snake, card, her goals were no different.

PROJECT CONCEPT

"I wanted a classy but striking snake with alternating color stripes to depict the snake skin pattern, but [added] alternating ornate patterns to give it a softer and different look, so it wouldn't be monotonous," Tam explains. "Striking red on the back gives it power, energy, and spirit and draws attention. Gold foil on the cover makes it glamorous, inviting, and mysterious against the black background. The satin ribbon makes the card softer."

COLOR DESIGN

Due to the built-in detail, the card required lots of handwork. It was printed and die-cut, then hand folded. The cover was glued and then the folded strip was glued together. Next, it was accordion folded and assembled into a little booklet. Finally, the ribbon was hand tied. In the end, the cards averaged $4 each.

IGX GLOBAL COMPANY BROCHURE

Client	IGX Global
Design Firm	GraphicType Services
Creative Director	John V. Cinquino
Art Director	Ravit Advocat
Copywriter	Everett T. Ruth
Palette	Green / Silver / Red / Dark Blue / Yellow / Violet / Light Blue / Orange / Dark Violet

PROJECT DESCRIPTION

"IGX Global is a hip, progressive technology company, and our main challenge was to develop a brochure to communicate their performance managed security solutions as well as capture their corporate culture—hands-on, intelligent, and passionate about their work," says John V. Cinquino.

PROJECT CONCEPT

Communicating this message successfully hinged on an aggressive color palette consisting of two dominant colors—lime green and metallic silver. "The lime green was critical in its selection as it had to not only convey advanced technology, but that the organization was progressive," says Cinquino. "Other blue hues were considerations, but it was determined that they would be too cool, typical, and not appropriate for the firm."

COLOR DESIGN

"Our atypical approach of using the metallic silver halftone for all photographs provided a unique contrast to the adjacent vivid flood of colors," adds Cinquino. "This combination and overlapping of colors created contrasting tension, invoking a feeling of constant movement."

No detail was overlooked in this project—down to the aluminum wire binding. Round holes, not square, were punched to complement the round die-cuts on the cover.

AGT RETAIL BROCHURE

AGT	Client
Grafik Marketing Communications	Design Firm
David Collins / Gregg Glaviano / Judy Kirpich	Designers
AGT	Photographer
Red / Gold / Black / Green	Palette

PROJECT DESCRIPTION

AGT's Retail Solutions brochure is all about color. AGT is a digital-media management company that assigned designers the task of showing the importance of color reproduction for retail clients.

PROJECT CONCEPT

Although the entire brochure was devoted to the message of accurate color reproduction, two interior spreads were of utmost importance. "When retail companies produce catalogs, it is important for the photos of the products to match the color of the original," says David Collins. "In these spreads, we found and photographed a number of pieces of red apparel that were similar in hue, but different. The headline asked, 'When is red not red?'"

COLOR DESIGN

The brochure was printed in eight over eight colors, including both process and match colors in its twelve pages plus cover. The brochure accurately communicates its message—and the reader is reassured that, in fact, AGT knows color. The next time a retailer is producing a color catalog and wants accurate reproduction, AGT is the company to turn to.

ORACLE "MOOVA SHEKKA" INVITATION

Client	Oracle
Design Firm	Cross Colours
Creative Directors	Joanina Pastoll / Janine Rech
Designer	Ria Kraft
Palette	Orange / Purple

PROJECT DESCRIPTION
Oracle retained Cross Colours to develop an invitation for the company's 500,000 satellite subscriber party themed Rhythms of Africa.

PROJECT CONCEPT
Designers sought inspiration for the Rhythms of Africa party invitation from South African jewelry created by miners who traditionally attach bottle tops to a wire, which they fasten over their gumboots to create a rattle for a celebratory dance.

COLOR DESIGN
Inspiration for the color palette came from the African landscape and its people. Yellow, pink, and blue bottle tops were attached with safety pins and beads, then enclosed in a vibrant orange and purple packaging.

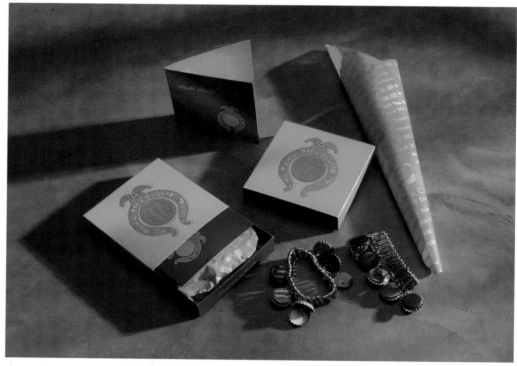

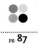

<div align="right">

MOD BUSINESS SYSTEM

MOD/Michael Osborne Design	Client
MOD/Michael Osborne Design	Design Firm
Michael Osborne	Art Director
Michelle Regenbogen / Paul Kagiwada	Designers
Lime / Plum / Cherry / Mango / Periwinkle	Palette

</div>

PROJECT DESCRIPTION

Michael Osborne Design was changing its branding to MOD and needed a look that was in keeping with its new name.

PROJECT CONCEPT

The change in branding was enhanced through the use of some modern, fresh colors—lime, plum, cherry, mango, and periwinkle—which rotate in different combinations on each element of the identity system. In fact, Michael Osborne's business card sports several variations and the colors used on the letterhead differ from the mailing envelope.

COLOR DESIGN

The colors were lithographed, whereas the text was letterpressed for added distinction. The MOD wordmark was created by digitally manipulating a variety of fonts to come up with a proprietary hybrid. Ganging up on large press sheets and then cutting down the sheets for the letterpress run gave designers the flexibility of using the wide-ranging color palette.

SPICERS PAPER MOVING ANNOUNCEMENT

Client | Spicers Paper
Design Firm | Giorgio Davanzo Design
Designer | Giorgio Davanzo
Palette | Apple Green / Warm Gray

PROJECT DESCRIPTION
Paper merchant Spicers Paper had expanded and needed a larger facility. Once settled in, they needed a way to announce their new location.

PROJECT CONCEPT
Incrementally larger die-cut squares combine to convey the message of growth in this direct-mail piece.

COLOR DESIGN
"The die-cut squares are positioned so that only a part of the copy—the word larger—can be seen when the card is folded," explains Giorgio Davanzo, designer. Green is the prominent color to designate the firm's growth that necessitated the move to a larger facility.

SYMANTEC SEASON'S GREETINGS CARD

Symantec Corporation	Client
Gee + Chung Design	Design Firm
Earl Gee	Art Director
Earl Gee / Fani Chung	Designers
Earl Gee	Illustrator
Green / Yellow / Brown / Blue	Palette

PROJECT DESCRIPTION

"Symantec Corporation, a global leader in computer software, sought a season's greetings card that would respect the seasons in both northern and southern hemispheres," says Earl Gee.

PROJECT CONCEPT

Color was used to symbolize the four seasons—green for spring, yellow for summer, brown for fall, and blue for winter—each with an appropriate icon of the season composed of the letters SYMANTEC.

COLOR DESIGN

The job was printed in five colors—process and yellow. "Soft process color gradations blend into each other as a metaphor for the blending of seasons throughout the year," adds Gee. The type treatment on the cover was set in Meta Plus Normal and was used on a path to draw symbols of the season.

HEAVENLY STONE STATIONERY PROGRAM AND LOGO

Client Heavenly Stone
Design Firm Hornall Anderson Design Works
Art Director Jack Anderson
Designers Jack Anderson / Henry Yiu
Calligrapher Taka Suzuki
Palette Red

PROJECT DESCRIPTION

Heavenly Stone, an art consultancy special-izing in contemporary Asian art, required a logo and stationery program that aptly reflected its products and services and turned to Hornall Anderson Design Works for help.

PROJECT CONCEPT

Designers immediately chose red as the key color for the image-building materials because Heavenly Stone specializes in Asian art, and red is known throughout Asian countries to symbolize good luck.

COLOR DESIGN

Since red is the only color in this palette, it would be easy to saturate everything with the color, but designers used the color sparingly—almost as an accent and trim color on the logo and letterhead system. To further reinforce the Asian theme, the sta-tionery program and folder were designed so that everything pulls out of the envelope and folder vertically since this is the same way the Chinese language is written and read.

FRANCHI FAMIGLIA PACKAGING PROGRAM

Franchi Famiglia	Client
Palazzolo Design Studio	Design Firm
Gregg Palazzolo	Art Director
Troy Gough	Designer
Earth Tones of Brown / Beige / Gold / Brown-red	Palette

PROJECT DESCRIPTION

Franchi Famiglia, makers of flavored olive oils and martini olives, sought a packaging system that differentiated it from the competition crowding store shelves and appealed to upscale customers of these products.

PROJECT CONCEPT

Palazzolo Design Studio took a look at the products and opted for an organic color palette. "The use of the organic palette goes nicely with the product," says Gregg Palazzolo. "The colors make a good connection with the brand and give the products its value, for example—natural, nonsynthetic, and pure."

COLOR DESIGN

Four-color process printing was used throughout the program except for the banded areas of solid color, which were printed as match colors for better control.

"There are many things in nature that have intensive colors," says Palazzolo, "but the subtle organic palettes of browns, creams, and oranges represent what is pure to nature."

Colorful Messages

by Leatrice Eiseman

Conventional wisdom has it that there is a rank order of visual elements that communicate visually. The most important element is believed to be written language or words. Words and language are followed in visual impact by the symbols that represent or replace the words, and they are followed by color. But even symbols must be colored so that they are more easily understood, such as the Red Cross and the yellow smiley face. So the argument can be made (as it often is) that color and sybols should be placed higher in the descending order listed above: colors, symbols, words, and language for the following reasons.

Color can transcend the limitations of words and reach across geographic boundaries. It is most often innately understood cross-culturally, triggering instant recognition of the intended message. An illustration or a photo of a red flame needs no explanation to express the inherent message: danger, pay attention, do not ignore! That dynamic, attention-provoking, flaming red connects emotionally and viscerally with the viewer however and wherever it is used.

When used in the marketplace, in the packaging, or on the printed page or Web site, color is a powerful persuader. The viewer must stop and look at the photo of the bright red bike or the red sportscar as it whizzes around turns in the television commercial. The product is literally imbued with the essence and energy of the vivid color. The reader or viewer gets it immediately and no words need be spoken.
The warmer colors of the spectrum, red, yellow, orange, yellow-green, and red purple, are considered the active colors, evoking immediate reactions from the consumer. They literally advance physiologically within the human eye and draw immediate attention. The so-called passive colors are connected with distance and the outer reaches and are in the cooler range, including light, medium, and deep blue, blue-greens, and blue violet. They are perceived as more reticent, calming, and quieting.

Each of these color categories can be used effectively to convey the appropriate message to the consumer, and most often, the effect is so subliminal that they are unaware of the psychological implications.

FOSSIL LINE SEGMENTS

Client	Fossil
Design Firm	Fossil
Art Director	Stephen Zhang
Designers	Jon Kirk / Dominique Pierron / Lana McFatridge / Jon Park
Phtographers	Dave McCormick / Russ Aman
Palette	Gold / Lavender / Black / Green / Blue

PROJECT DESCRIPTION

Fossil manufactures a myriad of watches for all age groups. In a unique attempt to color code its product lines, the company's in-house design studio has assigned color personas to each of its products to aid in appealing to its target audience.

PROJECT CONCEPT

Each product line has its individual features or characteristics that make it marketable to a particular audience segment. Designers took this information and developed color personalities for each line that communicate the watch features as much as any of the advertising copy.

COLOR DESIGN

Perhaps the most obvious color palette is for the watch line Blue, which designers aptly coded as blue—a color that in many cases symbolizes water and reinforces the headline, "You can swim in it!" Coincidentally, this line is targeted toward a masculine audience, so the choice of blue has the added sales advantage of appealing to men.

Arkitekt, a line of solid stainless steel watches, is more upscale and is targeted toward a mature and design-conscious audience, hence the choice of black for the line, which symbolizes the ultimate in sophistication.

F^2 is geared toward elegant and mature women, which explains the palette of gold and lavender.

Bigtic, a watch where you see the ticks as large numerals count off the seconds, is designated by green because designers felt that color best signified the high-tech nature of the line.

ABSORBA U.S. BRAND IDENTITY

Absorba	Client
Lieber Brewster Design	Design Firm
Anna Lieber / Elisa Carson	Art Directors
Aimee Youngs	Designer
Jade Albert	Photographer
Red / Navy / Cream / White	Palette

PROJECT DESCRIPTION

Absorba, a well-known brand of high-quality, fashionable, and luxurious baby-wear in France, asked Lieber Brewster Design to brand the company for the U.S. market.

PROJECT CONCEPT

The identity developed by Lieber Brewster sends an unmistakable message that this clothing is French due to the use of red, navy, and white—the colors of the French flag—along with a secondary palette of cream.

By visually conveying that the products are French, designers also succeeded in communicating a variety of value-added features as a result. When something is French, U.S. consumers translate that to mean it is fashion-forward, luxurious, and desirable.

COLOR DESIGN

The flood-coated pocket folder is where the secondary palette appears—namely, a cream color, which is also associated with all things French. This folder provides a dramatic backdrop for the vibrant photography of children dressed in Absorba clothing. In all, the package is playful, fun, and upscale—all the things that characterize this line of kids' clothing.

THEATERSPORT POSTER

Client	Theater IMPROphil
Design Firm	Mix Pictures Grafik
Art Director	Erich Brechbühl
Designer	Erich Brechbühl
Palette	Green / Red

PROJECT DESCRIPTION

Theater IMPROphil, an improvisational theater group, tapped Mix Pictures Grafik to develop a poster promoting their performance running April 20 through May 19, 2001.

PROJECT CONCEPT

Designer Erich Brechbühl decided to use an abstract art design in two complementary colors—red and green. By colorizing some of the letters in the design that spell out the word "theater" in red and laying them on top of the green, the colors mix to form a third color, which is a visual metaphor that communicates what this theatrical organization is all about—improvisation.

COLOR DESIGN

Brechbühl created the artwork in Freehand and printed it on poster paper in just two colors, yet the result appears to be four colors as a result of the ink overlapping to form a third hue and the generous use of white, unprinted paper.

CHASSIS BROCHURE

Arcabia	Client
5D Studio	Design Firm
Jane Kobayashi	Art Director
Anne Coates	Graphic Designer
De/Veda	Photographer
Metallic Silver / Match Orange	Palette

PROJECT DESCRIPTION

The selling feature behind the new Chassis chair by Arcabia is that it offers a "slip-on vest" that can be customized with choice of fabric and color to tailor the chair specifically to the buyer's specifications.

PROJECT CONCEPT

For the purposes of a new marketing brochure, the client chose to outfit the Chassis chair with a bright orange "slip-on vest" to draw attention to the feature. Since the chair itself is a mixture of chrome, black, and beige, the choice of an orange accent dictated the color palette for the design.

COLOR DESIGN

Throughout the piece, orange is woven in as an accent color, except for the center panel shot. Here, the designers went all out to drive home the message. "We used orange iMacs and desk accessories to accent the orange," says Jane Kobayashi.

On the last page of the brochure, designers enjoyed incorporating a halftone image in orange with a metallic silver background and silver highlights. In all, an interesting treatment for orange, which is an under-used color.

Arcadia

FRIA BABY WET WIPES PACKAGING

Client Diva International
Design Firm Studio GT + P
Art Director Gianluigi Tobanelli
Palette Yellow / Blue / Pastels

PROJECT DESCRIPTION
There are a lot of baby wipes on the market, so Diva International needed a packaging concept that would help its product stand apart from the competition on store shelves.

PROJECT CONCEPT
Gianluigi Tobanelli chose a yellow background for the package to distinguish it from its competitors (other products use either pink or green) and heighten its visibility in a crowded marketplace. He included a dolphin graphic, which he colored in pastels to underscore the softness of the product designed for babies.

COLOR DESIGN
The artwork was created in Adobe Photoshop and Freehand. The film portion of the packaging was reproduced in six-color gravure printing, whereas the label was printed in five colors.

ROSWELL PRINT AD

Omni Media	Client
After Hours Creative	Design Firm
Russ Haan	Graphic Designer
Red	Palette

PROJECT DESCRIPTION

Omni Media wanted an ad to promote a new CD-ROM that told the story of the incident at Roswell, New Mexico, where the government purportedly covered up the crash of a UFO.

PROJECT CONCEPT

The ad used a simple tactic—using a flood of red with only minimal type and a tiny photo. "The impact of the huge amount of red brings the magazine reader to a halt," says Russ Haan. "The tiny image of the alien is almost voyeuristic, so you feel like you're peeking into a place where you're not allowed, and the little bit of copy is humorous, so you know this piece takes itself lightly."

COLOR DESIGN

"The ad uses the color red to do a number of things," adds Haan. "First, red is the color of warning, the product is all about the secrecy of information pertaining to UFOs, particularly the incident at Roswell, New Mexico. It also grabs attention and stops the reader in mid-browse. Finally, it works like an exclamation point, conveying excitement."

HERMAN MILLER 2001 ANNUAL REPORT INNOVATION

Client | Herman Miller
Design Firm | BBK Studio
Art Directors | Yang Kim / Steve Frykholm (Herman Miller)
Designers | Yang Kim / Michele Chartier
Illustrator | Michele Chartier
Palette | Black / Blue / Orange / Magenta / Gray

PROJECT DESCRIPTION

Herman Miller, maker of contract furniture, dubbed its 2001 annual report *Innovation* and called upon BBK Studio to give it form.

PROJECT CONCEPT

In a drastic turn from previous years' annual reports, designers reasoned that a lack of color—or just using black—provided enough innovation design-wise to measure up to the title of the report. "How often do you see an annual report that's just black?" asks Yang Kim, BBK Studio. "Color wasn't important to this concept so black was the logical choice."

COLOR DESIGN

The report isn't just black type; it includes a secondary palette of blue, orange, magenta, and gray along with four-color process, which was used for the internal photography. However, giving the black its sophistication, single-mindedness, and unique character is the use of Glamma stock. As readers flip through the pages, they see only a few words of copy at a time. This slow, timed-released display of black text sends a precise, unadorned message that cuts through the clutter. There is no frivolous copy here; this back-to-basics messaging gets noticed because it indicates importance.

SYDNEY BREAST CANCER INSTITUTE CORPORATE IDENTITY

Sydney Breast Cancer Institute	Client
Cato Purnell Partners Pty. Limited	Design Firm
Pink	Palette

PROJECT DESCRIPTION

Sydney Breast Cancer Institute sought a corporate identity and tapped Cato Purnell Partners to deliver one.

PROJECT CONCEPT

Colors have long been associated with causes, but some have become so identifiable with the cause they represent that they are inseparable. One example is the red ribbon, a universal symbol for AIDS. Likewise, we've come to associate breast cancer with the color pink. Although this has been a fairly recent phenomenon, today, the color pink and awareness for breast cancer are considered one and the same.

COLOR DESIGN

"Breast cancer—[those] are words with exceptionally strong visual connotations. Connotations of flesh, female, sensitive, and the pink environment for the symbol and typography leaves no one in doubt as to the field of research of this medical institute," say designers at Cato Purnell Partners.

SYDNEY
BREAST CANCER
INSTITUTE

QANTAS AIRLINES MENU COVERS

Client	Qantas Airlines
Design Firm	Cato Purnell Partners Pty. Limited
Palette	Desert Ochre / Reds / Gray-Greens / Blues

PROJECT DESCRIPTION

Cato Purnell Partners was retained to develop menu covers for use in the first-class cabin on Qantas Airlines' international flights.

PROJECT CONCEPT

The design uses no copy or logotypes. Instead, Cato Purnell Partners developed an identity for Qantas based on the Australian landscape, using colors and textures indigenous to the country.

COLOR DESIGN

The designs are reproduced full color in palettes of golds and reds to represent the Australian Outback and mountainous regions as well as the gray-greens and blues of the coastal regions. The artwork is reproduced in squares on high-gloss pressure sensitive paper and placed into debossed squares on 12-inch (30-centimeter) square heavy menu covers. "The vibrant squares of color photography describe our country better than any words," say designers at Cato Purnell Partners.

EYECANDYTV.COM IDENTITY

eyecandytv.com	Client
Blok Design Inc.	Design Firm
Vanessa Eckstein	Art Director
Vanessa Eckstein / Frances Chen / Tony DeFrenza	Graphic Designers
White / Yellow / Silver	Palette

PROJECT DESCRIPTION

Eyecandytv.com tapped Canada's Blok Design to develop an identity that would be as leading edge and unique as the company, which is pioneering Internet television programming.

PROJECT CONCEPT

Nothing staid and traditional would do for this venture; Blok Design had to come up with something different. The designers' solution was to develop a white-on-white letterhead system featuring blind embossing with an eye-popping, show-stopping splash of sunny yellow on the reverse of the letterhead and inside the envelope. The yellow—seen as fresh and innovative—makes one stop and take notice because it is so unexpected.

COLOR DESIGN

"The design had to both differentiate itself from the existing market—very virtual/high-tech—and distinguish itself as a young, unique proposition in television," says Vanessa Eckstein. "From a bold yellow color, as the only color through the entire identity to subtle uses of white on plastic and white on white, it invites the audience to question and be intrigued by the many forms and materials this identity presents."

"Surprise was a fundamental part of the challenge, as well as a no-nonsense stylistic approach," Eckstein adds.

NANOCOSM TECHNOLOGIES, INC. LOGO

Client	Nanocosm Technologies, Inc.
Design Firm	Gee + Chung Design
Art Directors	Earl Gee / Fani Chung
Designers	Earl Gee / Fani Chung
Illustrators	Earl Gee / Fani Chung
Palette	Warm Red / Green / Purple / Black

PROJECT DESCRIPTION

Gee + Chung Design was hired by Nanocosm Technologies, Inc., an Internet finances company, to develop a logo and stationery system that would reflect its leading-edge technology.

PROJECT CONCEPT

To communicate the variety of financial services the company offers via the Internet, designers created a logo with different colored cores. "Streaming bits of information flowing over the colored core create the illusion of depth and reveal the letter N," explains Earl Gee.

Next, the green logo was applied to the letterhead, the red logo to the business card, and the purple version to the mailing envelope. "The soft, subtle front sides of the business card, letterhead, and envelope create a striking contrast with the strong vivid backsides of the items," adds Gee.

COLOR DESIGN

The logo was embossed to emphasize the dimension quality of the logo, which designers say is most effective in fine line screens of 150 lpi or more. In fact, they claim that if you hold the letterhead to the light, the color core appears to glow like neon, adding an element of intrigue for the recipient.

In total, the system is very colorful, yet each piece is printed in only two colors and elements were ganged on the same sheet to contain print costs.

ART CENTER COLLEGE OF DESIGN ALUMNI COUNCIL LOGO

Art Center College of Design Alumni Council	Client
Gee + Chung Design	Design Firm
Earl Gee	Art Director
Earl Gee	Designer
Earl Gee	Illustrator
Orange	Palette

PROJECT DESCRIPTION

The Art Center was a design school in need of a logo. Gee + Chung Design, a San Francisco–based firm, agreed to provide the inspiration and artwork.

PROJECT CONCEPT

Using just one color—orange—Gee + Chung Design created a memorable logo for the design school, one that is totally unlike what might be expected of an educational institution. It is only a series of orange dots, but in this case, the design represents how the Alumni Council connects the orange dots, which is a visual metaphor for a circle of creative individuals linked by common experience.

COLOR DESIGN

"The logo communicates a sense of connection, community, support, and unity," says Earl Gee. "The varying perspectives of the orange dot reflect the diverse backgrounds and different views shared by Art Center alumni."

JOSÉ EBER MEDIA KIT AND IDENTITY

Client	José Eber Atelier
Design Firm	44 Phases
Art Director	Yu Daniel Tsai
Designers	Yu Daniel Tsai / Luis Jaime / Prances Torres / Marco Pinsker / Chalalai Haema
Digital Retoucher	Yu Daniel Tsai
Photographers	John Russo, Kevin Ackerman
Palette	Green / Yellow / Orange / Maroon / Gray / Red

PROJECT DESCRIPTION

José Eber Atelier, the upscale Rodeo Drive beauty salon, was in need of a media kit and identity system that spoke to its upscale approach to beauty.

PROJECT CONCEPT

Designers developed a theme for the salon called "Essence of Colour—Shades of Hue," which includes colors for each season. This color palette of green, yellow, orange, maroon, gray, and red is played out on everything from letterhead to business cards and miniature translucent envelopes—perfect for discreetly leaving behind a tip.

COLOR DESIGN

There are more than ten different typefaces used in the design of these materials that parallel the use of colors, which appear on all the pieces. Business cards, letterhead, and other materials appear in all the hues of the palette, not just one. Likewise, the media kit follows the same palette, but here the photography of women with luxurious hair color stands on their own; they compete with only a white background

To achieve as many colors as possible with a matte look and feel, designers printed the business cards on a glossy paper, then applied a satin aqueous coating.

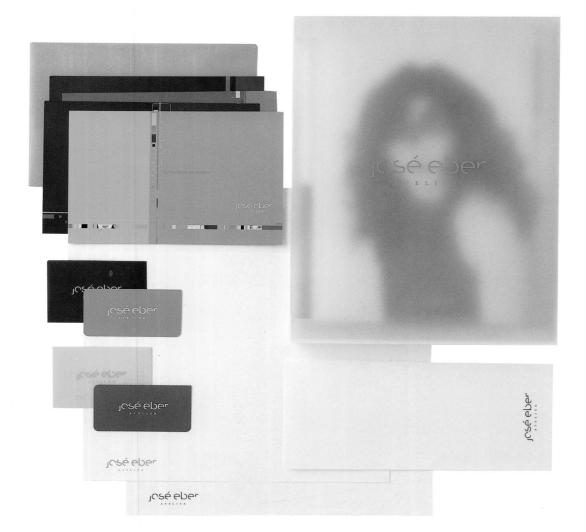

Monterey Pop Revisited

Looking Back at 1967

It was the beginning of the "Summer of Love" and the motto for the festival was "Music, Love and Flowers." Lou Adler and John Phillips presented one of the greatest rock & roll shows of all time. They brought together such diverse talents as Jefferson Airplane, Simon & Garfunkel, Buffalo Springfield, Lou Rawls, The Grateful Dead, Country Joe & the Fish, Otis Redding, Ravi Shankar, Hugh Masakela, Eric Burdon and the Animals, Canned Heat, The Byrds, The Mamas & the Papas, The Paul Butterfield Blues Band, and The Association. Also on the three-day bill were relative unknowns like Janis Joplin (Big Brother and the Holding Company), The Who, and The Jimi Hendrix Experience.

The Monterey International Pop Festival happened only once, but it served as the blueprint for all future rock festivals, including Woodstock. It was a magical, pure moment in time.

"Monterey was the purest, most beautiful moment of the whole 60's trip. It seemed like everything had come to that moment. It was a magical, pure moment in time."

2001

June 15, 16 & 17
at the Monterey
Fairgrounds

A symposium and exhibit examining the context, meaning and beauty of 1967's Monterey International Pop Festival experience.

For more information or reservations, visit popfestmonterey.com or call toll free, 866-POP-FEST

DENNIS HOPPER

PROMOTION FOR MONTEREY POP REVISITED

The Monterey History and Art Association	Client
KBDA	Design Firm
Liz Burrill	Designer
Hot Pink / Acid Yellow / Bright Orange / Light Blue / Light Green / Teal	Palette

PROJECT DESCRIPTION

KBDA was asked to create promotional material for a symposium on the Monterey Pop Festival of 1967, sponsored by the Monterey History and Art Association. The purpose of the event was to increase tourism by bringing together famous historical pop musicians, directors, and producers of the original event. The project included supporting literature and a Web site used for registration and general information.

PROJECT CONCEPT

Since the symposium was centered on a historic music festival, it made sense to incorporate design elements from the original event into the current project. KBDA researched material culture of the 1960s including style, fashion, and music. Working from the intricacies of the original promotional materials, KBDA designed a new logo of abstracted circular forms with handwritten letters.

COLOR DESIGN

Intense 1960s colors—pinks, blues, and oranges—combined with "posturized appearing" photographs created high-contrast images. With the hope of appealing to old returnees and new, young enthusiasts, pea green was combined with the 1960s colors as the dominant background color. It gave the project a feeling of a bit of nostalgia combined with cutting-edge freshness. Five hundred people attended.

Color—
True or False?

by Leatrice Eiseman

Blue is always associated with serenity and dependability.
FALSE.

Beware the overgeneralized color concepts in any color family. Light, midtone, and deeper blues are associated with certain constants in our environment, such as the sky, the sea, and the outer limits. However, just as the name implies, bright electric blue evokes greater energy and excitement.

The use of orange in print, packaging, advertising, or the product itself cheapens the value of the product.
FALSE.

Although the advent of "fast-food orange" lent a tacky connotation to the color, the 1990s brought about a new recognition and fascination for orange as it was used in more exotic contexts by diverse cultures. Couture fashion designers introduced orange into their collections and currently the color is more widespread at every level of the marketplace.

Brown is the embodiment of all things organic, natural, wholesome, and earthy.
TRUE.

Although it is true that brown has traditionally been thought of as a "Mother Earth" kind of color and can still be used within that context, it is a shade that has seen some changing consumer responses. Largely because of the designer coffee phenomena, the shade has taken on a whole new dimension with many consumers now perceiving the brown family as rich and robust.

Kids best accept vibrant yellow-greens.
TRUE.

Although it is true that kids love bright, eye-popping chartreuse yellow-greens, they are not amongst adults' favorite colors. It is a color that intermittently explodes on the scene and then periodically disappears, but it is a powerful, albeit youthful or trendy, presence on the printed page or a Web site. As the yellow green is lowered in intensity, the acceptance level rises for adults.

Red is the most visible of all colors.
FALSE.

Although red may aggressively demand attention, it is not the most visible of all colors, particularly at twilight when the light is starting to wane. Yellow is actually the most visible, especially when combined with black.

COVER DESIGN FOR MEMBERS' JOURNAL

Client: Art Gallery of Ontario
Design Firm: Dinnick and Howells
Graphic Designers: Sarah Dinnick / Jonathan Howells
Palette: Spectrum Colors

PROJECT DESCRIPTION

The Art Gallery of Ontario asked Toronto-based Dinnick and Howells to create a cover design for their members' journals.

PROJECT CONCEPT

The idea revolved around the need to create a standard design with flexibility that could change monthly in accordance with the featured artwork.

COLOR DESIGN

The type, logo, and graphic design remain constant, whereas the color changes with respect to the artistic image. The color never overpowers the image; rather, it identifies with the piece in terms of period and style.

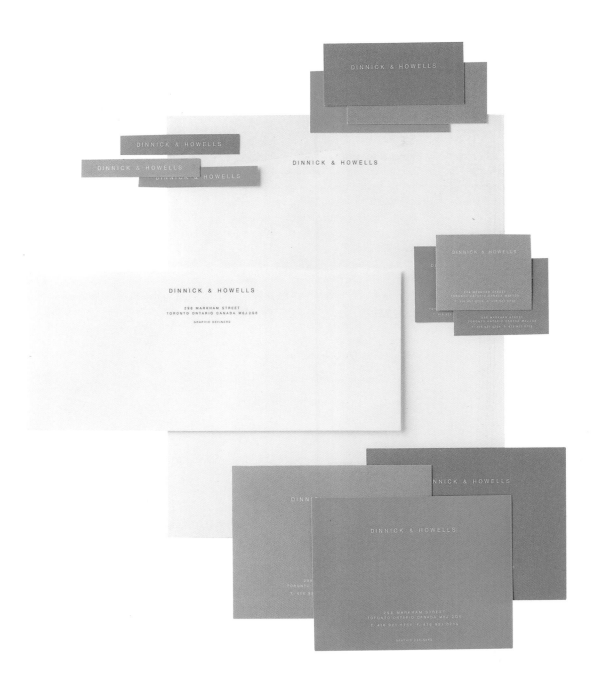

STATIONERY AND MAILING TAGS FOR DINNICK AND HOWELLS

Dinnick and Howells	Client
Dinnick and Howells	Design Firm
Sarah Dinnick / Jonathan Howells	Creative Directors
Warm Gray / Warm Greens / Blues / Oranges	Palette

PROJECT DESCRIPTION

The purpose was to create stationery and other branding materials for the graphic design firm Dinnick and Howells.

PROJECT CONCEPT

Calling themselves "graphic definers," Dinnick and Howells wanted to create stationery materials that combined a simple, understated feeling with a mood of bright, vibrant energy.

COLOR DESIGN

The color in the materials reflects the designers' desire to define themselves as they would their other projects. The use of warm gray with simple, but dimensional, engraved Helvetica type and warm green, blue, and orange backgrounds evokes a vibrancy that is both attractive and welcoming to the client.

LINEAR TECHNOLOGIES 2000 ANNUAL REPORT

Client	Linear Technologies
Design Firm	Cahan and Associates
Creative Director	Bill Cahan
Designer	Todd Simmons
Palette	Spectrum Colors

PROJECT DESCRIPTION

Linear Technologies Corporation designs and manufactures advanced analog semi-conductors (integrated circuits for managing power consumption) that make products based on digital microelectronics smaller, faster, and better.

PROJECT CONCEPT

The entire concept is based on the idea that the use of semiconductors is essential to continual digital tone. The physical size and shape of the report itself mimics a hand-held organizer to evoke the idea of smaller, faster, and better.

Cahan and Associates wanted nothing to interfere with the integrity of the words. They designed two books: a colorful one, written as a clear and concise statement with no imagery and a black-and-white book, with no decipherable message.

COLOR DESIGN

Cahan used linear gradation to make the point that semiconductors are the backbone for smooth digital transmissions. The linear gradation creates a visual cycle colorfully beginning where it ends. Two books are enclosed together in a cover that uses two linear gradations. The contrast between a book in black and white and a colorful book highlights the importance of linear technologies product, while the combined packaging shows their interdependence.

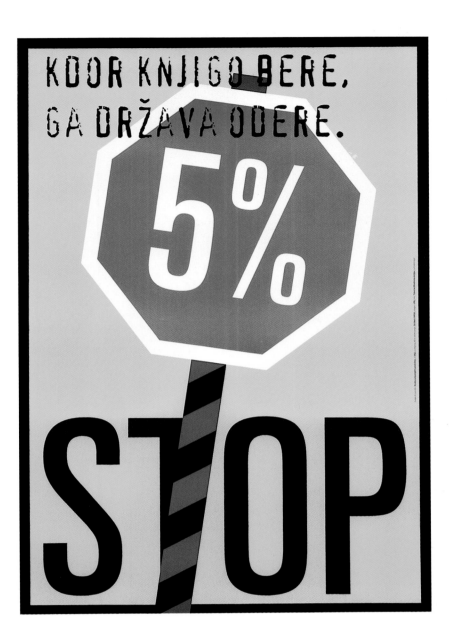

B/ STOP POSTER

Drutvo zaloænikov Slovenije — Publishers Society of Slovenia, Ljubljana — Client

KROG — Design Firm

Edi Berk — Creative Director

Intense Red / Yellow / Green / Black — Palette

PROJECT DESCRIPTION

Edi Berk was asked by Drutvo zaloænikov Slovenije — Publishers Society of Slovenia, Ljubljana, to create a poster designed for a campaign to help publishers achieve the lowest possible taxes on books.

PROJECT CONCEPT

The idea for the piece was based on the incongruous nature of making someone who reads a book pay a tax to the state treasury, thus making the attainment of knowledge more costly. The piece points out that this is contrary to the idea of wanting an increasingly educated public.

COLOR DESIGN

Berk used bright colors purely as an attention-getting device. The red of the stop sign reinforces the commonly understood meaning of "stop!"

LETTERHEAD FOR WATERWORKS OF LJUBLJANA

Client Waterworks of Ljubljana
Design Firm KROG
Creative Director Edi Berk
Palette Bright Blue / Turquoise / Pink / Green

PROJECT DESCRIPTION
Vodovod-Kanalizacija of Ljubljana Waterworks asked Edi Berk to create letterhead as part of a wider campaign that celebrated their 110 years of supplying water to Ljubljana.

PROJECT CONCEPT
The piece focused on the concept of the circulation of clean and healthy water. Depiction of water movement was very much a central image, along with a photo of the lion's head fountain that is situated near the client's headquarters.

COLOR DESIGN
Berk used bright colors to catch the people's attention. In addition, he used water blues and greens to represent the natural environment of land and water. He wanted the viewer to identify with the cleanliness and self-purification of nature.

IDENTITY FOR AN EDUCATION CENTER

The Bank Association of Slovenia	Client
KROG	Design Firm
Yellow / Cobalt Blue / Grass Green / Orange Red / Medium Purple / Light Orange	Palette

PROJECT DESCRIPTION

The Bank Association of Slovenia asked Edi Berk to create an identity for their new education center that gives additional education to bankers.

PROJECT CONCEPT

The idea behind the identity program was that knowledge is power, design is power, and strong design can communicate the idea that knowledge is power. It presumes that typefaces and characters are the basics for education.

COLOR DESIGN

The strong, intense colors reinforce the strength of the design, which in turn supports the symbolic idea that education is power.

TRINET REBRANDING PLAN

Client	TriNet
Design Firm	Kirshenbaum Communications
Creative Director	Susan Kirshenbaum
Designer	Jim Neczypor
Illustrator	Doug Ross
Copywriter	Lessley Berry
Palette	Orange / Periwinkle Blue / Green

PROJECT DESCRIPTION

TriNet outsources comprehensive Human Resources (HR) services to growing businesses. The company wanted an updated brand identity to reflect their new integration of Internet tools and technology into their products and services.

PROJECT CONCEPT

To distinguish TriNet from its competitors, Kirshenbaum Communications created an entirely new marketing program to reflect an organization that is technology-based, yet has a strong human element. Along with rebranding the company, recreating its identity, and redesigning its logo, they developed a tagline, brand standards manual, business system marketing kit (folders, inserts, and templates), and corporate brochure.

COLOR DESIGN

Three colors are used to represent the three different areas of the business. Kirshenbaum suggested that TriNet leave the old turquoise for a more current, Web-friendly color system that is more youthful and energetic. Colors were designed for the Web, process, and print.

EXCEED THE LIMIT DIRECT-MAIL CAMPAIGN

Logility	Client
Crawford/Mikus Design Inc.	Design Firm
Elizabeth Crawford	Art Director
Elizabeth Crawford	Graphic Designer
Red / Green	Palette

PROJECT DESCRIPTION

Logility, a division of American Software specializing in supply-chain management, asked Crawford Mikus to create a two-phase direct-mail campaign to increase lead generation for salespeople.

PROJECT CONCEPT

To reinforce the idea of smooth and accurate movement through the supply chain, Crawford Mikus designed the Exceed the Limit pieces with layered graphics to create a feeling of speed and motion. To maintain cost efficiency and allow for repetitive information to be conveyed, they chose to print the piece in two different color schemes.

COLOR DESIGN

Color change was at the conceptual basis of the piece, in that it created viewing variety in an eye-catching way, but conveyed the same message.

BOOK AND PROMOTIONAL POSTER FOR GAUDEAMUS IGITUR

Client Dræavni Izpitni Center–Examination Centre of the Republic of Slovenia
Design Firm KROG
Creative Director Edi Berk
Palette Yellow / Red / White / Green / Lavender

PROJECT DESCRIPTION

Berk was asked by the Dræavni Izpitni Center–Examination Centre of the Republic of Slovenia, Ljubljana, to develop a book that explains the graduate celebration known as "matura," and acts as a guideline for recent graduates who might want to incorporate customs into their own "matura" rituals.

PROJECT CONCEPT

The design concept stemmed from the target audience of eighteen-to nineteen-year-olds that Berk considered to be a young and energetic, computer-oriented generation that loves to experience life.

COLOR DESIGN

Berk created a mood with the color that he thought would appeal to an active, youthful age group. The poster used bright colors and unusual typography to catch a person's attention and enhance and clarify the image.

TOY COMPANY IDENTITY PROGRAM

Smobey	Client
Metzler and Associates	Design Firm
Mark Antoine Herrmann	Creative Director
Light Blue / Red / Yellow	Palette

PROJECT DESCRIPTION

Smobey, the world's fifth-largest toy company, asked Metzler and Associates to create a new packaging and corporate identity for its business.

PROJECT CONCEPT

Metzler and Associates used Smobey's mission statement "to help kids grow and learn while playing" as the basis of their design. They created an image to represent children of all ages and "the kid within us," which incorporates the growing kid into the logo.

COLOR DESIGN

Metzler believes that identities for children's products work most efficiently with the use of bold and primary colors. The corporate colors chosen were red and blue and the packaging used blue, red, yellow, and black.

Walter Zdrazil, Austria

DESIGN STRATEGY FOR IBM'S *THINK* Magazine

Client	IBM
Design Firm	VSA Partners
Creative Director	Curtis Schrieber
Designers	Susana Rodriguez / Hans Seeger / David Ritter
Copywriter	Mike Wing
Palette	Orange / Blue

PROJECT DESCRIPTION

IBM partnered with VSA Partners to come up with a new design strategy for their premier Internal publication, *Think* magazine.

PROJECT CONCEPT

The idea was to consolidate the content, talking about one issue instead of several, to give the publication more impact. The new masthead used in combination with the color and design created a bold and graphic look.

COLOR DESIGN

The magazine adopted a simple complementary color palette of orange and blue to reinforce the focus of the content. The bold color enhances the strength of the publication.

INVITATION TO LEVI STRAUSS PROMOTIONAL PARTY

Levis	Client
re:public	Design Firm
Athena Windelev	Creative Director
Athena Windelev	Art Director
True Blue	Palette

PROJECT DESCRIPTION

Re:public was asked to create an invitation for a promotional party held in a private home for Levi's.

PROJECT CONCEPT

The idea was to be all-inclusive. Everyone that was invited was on the invitation. Levi's is known to be the "true blue," so they strove for authenticity.

COLOR DESIGN

To enhance the true-blue quality, re:public chose to print a classic blue, almost inklike color, on inexpensive paper to make the invitation tie in with Levis' identity.

GRAPHICS FOR THE PALACE AT AUBURN HILLS

Client Palace Sports and Entertainment
Design Firm Kiku Obata and Company
Creative Director Kiku Obata
Photographer Gary Quesada / Hedrich Blessing Photographers
Palette Yellow / Red / Blue

PROJECT DESCRIPTION
In order to make the twelve-year-old Palace of Auburn Hills, home of the Detroit Pistons, competitive with today's newer facilities, Kiku Obata and Company developed phased improvements to the concourse concessions, environmental graphics, and lighting.

PROJECT CONCEPT
The idea behind the design was to create an exciting, vibrant identity for a facility without being team specific.

COLOR DESIGN
The concession stands and the way-finding graphic system for the concourses utilize a bold and bright color scheme. The colors were selected to give an entertainment and sports feeling but not to be team specific. The new color palette and dramatic lighting give life to the concourses that were dark and colorless before the renovation.

A PROMOTIONAL POSTER FOR PIDDLERS TOILET TARGETS

Silly Goose Company	Client
Fellers Marketing and Advertising	Design Firm
Bryan Pudder	Art Director
Bryan Pudder	Creative Director
Bryan Pudder	Illustrator
Bright Yellow	Palette

PROJECT DESCRIPTION

The project was The Potty, a promotional poster designed for Piddlers Toilet Targets manufactured by the Silly Goose Company. The piece was to be included in a response to inquiry about Piddlers Toilet Targets, biodegradable devices in funny shapes that allow for easier potty training. It was also considered as a point-of-purchase piece for retailers.

PROJECT CONCEPT

The objective of the piece was to very clearly convey the selling point of "pee goes where it belongs." Since the product affects both parent and child, Fellers wanted to create a childlike way to simply communicate the selling point. The result was a kid's drawing for an adult's benefit. The drawing was colored to push the childlike quality.

COLOR DESIGN

They chose yellow because "yellow is the color that communicates urine."

 Piddlers Toilet Targets They're simple and fun. Just drop one in the toilet, and start tinkling. They melt away on contact. A great way to make potty training easy on everybody. www.piddlers.com

4

Color That Evokes Emotion

Color that evokes emotion is by far the broadest type of color usage. We do not live in the black-and-white world of the film *Pleasantville*. Rather, we live in an increasingly colorful world that is filled with emotions, feelings, and associations. Everything from curtains on the wall to our toothbrushes has become a color statement. It has led us to have to define and redefine our response to color. To strengthen our design we must carefully understand the target market and find out what their response might be.

This response is determined by color culture—the response that the viewer has to color because of sociological, historical, political, geographical, and psychological reasons. Color that evokes emotion is not a direct response to obvious associations as in primary message color, or intuitive as it is in color that persuades, but comes from the depth of personal experience and may vary by individual or culture. Purple is viewed quite differently around the world— in some Asian cultures, purple is affiliated with royalty, whereas in the United States, there is no such affiliation.

Color can be used to evoke the pleasantness of an environment or a region. For example, blue-green and a warm yellow may evoke the feeling of the tropics whereas desert red and browns might suggest the New Mexico desert. Blue, white, and chrome are repeatedly used in Design Forum's prototype for the West Marine chain because the palette evokes a feeling of boating and the sea. Metzler and Associates used the color of provincial France for the French airline Air Littoral to create an identity and tie the airline's services to the region.

Evocative color can be drawn from a smell or a musical piece. The Soho Spice restaurant in London used the color of spices to enrich its Indian decor. Troxler's Jazz Blvd book cover and poster use images stemming from the sound of the music, the motions of the musicians, the style of the instruments, and are supported by his strong color visualization.

Nostalgia for a different time period is often important in a design. 1960s colors were intrinsic to the design of the play poster for *New Patagonia* by Ames Design. The green prevalent in the electronic world of the 1980s was used in the Jester's *Digitalia*

CD cover designed by F3. Pink was used on the auction poster for Marilyn Monroe to identify her and her bright clothing and was also reference to the "pop-ish" colors of the 1950s and 1960s.

Emotive color can have symbolic meaning. In the Chela Financial Corporate report by Kirshenbaum Communications, yellow represented gold (money), the process of education (school buses and pencils), and a path toward a better future (the yellow brick road). Red has great symbolic meaning. Lanny Sommese used red to represent blood, death, and fear in his Stop poster.

Emotive color may be used in the broadest fashion but it is the type of color that is by far the most complex. While difficult to control because people's responses will vary, understanding and utilizing color meaning will lend great impact to your design.

KONFETIE JEWELRY POSTCARD CATALOG

Client	Konfetie Jewelry—Jenn Fenton
Design Firm	The Riordon Design Group
Creative Director	Ric Riordon
Designers	Amy Montgomery / Shirley Riordon
Photograper	David Graham White
Palette	Purple / Fuchsia / Lime / Turquoise / Orange

PROJECT DESCRIPTION

Jenn Fenton is an upbeat jewelry designer, whose firm, Konfetie is known for its handmade beaded jewelry. Fenton needed a catalog that reflected her products and, in particular, her influence and unique design style.

PROJECT CONCEPT

Fenton's jewelry plays to seasonal colors and current trends, but the real key to Konfetie's success is Fenton herself. Her vibrant personality is as much a part of the company as the jewelry she creates. When the Riordon Design Group entered the picture, designers felt that any product catalog should reflect Fenton's personality as much as the design.

COLOR DESIGN

To communicate Fenton's captivating nature and penchant for the unusual, the Riordon Design Group chose a palette that imitated her personality—uplifting colors of purple, fuchsia, lime, turquoise, and orange—and which perfectly complemented her colorful beaded creations. Designers developed a series of six postcards—primarily to eliminate the need for any binding—that allows for new cards to be easily integrated into the system as needed. The postcard catalog arrives in a confetti-speckled vellum envelope, which further keeps the tone light, fun, and whimsical—just like the creator and her creations.

FORMAT DESIGN SELF-PROMOTION

Format Design	Client
Format Design	Design Firm
Knut Ettling	Designer
Knut Ettling	Illustrator
Blue	Palette

PROJECT DESCRIPTION

Format Design's self-promotional mailer and leave-behind highlights the firm's graphic design work for print, corporate, and Web-based projects.

PROJECT CONCEPT

Knut Ettling chose blue as the corporate color for Format Design, primarily because it is simple, memorable, and easy to associate with his firm.

COLOR DESIGN

"Format Design is the blue company," says Ettling. Why blue and not another color? "I like it; it fits me. It is fresh and positive, like the sky." Moreover, he adds, "There is no other design company in this area using a similar color." The resulting brochure is compact and cleanly designed. The plastic translucent itself is eye-catching; the brochure tucked inside is streamlined and expertly designed with an embossed cover and round corner die-cuts. Examples of Ettling's work are sprinkled throughout the inside four-color process pages, which contrast nicely with the blue cover.

INTERNATIONALES JAHRBUCH KOMMUNIKATIONS—DESIGN 1996/97 BOOK

Client Verlag Form, Frankfurt am Main
Design Firm Büro für Gestaltung
Art Directors Christoph Burkardt / Albrecht Hotz
Palette Violet / Lavender / Blue / Orange / Pink / Teal / Yellow / Green

PROJECT DESCRIPTION
Design the cover of a graphic design annual—that was the task set before designers at Büro für Gestaltung, who tackle the project annually and always strive to do something different to keep the book's appeal fresh.

PROJECT CONCEPT
Every year when the book comes out, designers try to find a different abstract picture that will work as the lead cover image—after all, it is the cover image on any book that motivates a potential buyer to make an actual purchase. In the case of a design annual, even more importance is placed on the cover image because it must attract the toughest audience of all—skeptical graphic designers.

COLOR DESIGN
They opted to base this cover image on color and no two colors are alike. The job was printed in four-color process and each color is different—if only by about 10 percent. All these different colors, together with the unique layout, result in a three-dimensional effect.

STEPHAN TOURISTIK POSTERS

Stephan Touristik	Client
Büro für Gestaltung	Design Firm
Christoph Burkardt / Albrecht Hotz	Art Directors
Aqua / Yellow	Palette

PROJECT DESCRIPTION

Stephan Touristik, a German travel agency that deals exclusively in trips to Latin America, needed some eye-catching promotional materials that would convey the mood and feel of the getaways they offer.

PROJECT CONCEPT

Because the agency deals exclusively in trips to South America and environs, they needed a look that communicated warm, sunny destinations—and conveyed a sense of carefree abandon that makes a person who is dragged down by daily life want to get away from it all.

COLOR DESIGN

To accomplish their goal, the design team knew they needed colors that were fresh and uplifting. By choosing such a palette, the posters would look like a departure from everyday life and visually appear to lift some of the burdens from travelers' shoulders even before the holiday begins.

Specifically, they wanted the palette to reflect a hot side—or the sun—as desig nated by yellow and a cool side to represent the sea as denoted by a shade of teal. Designers digitally manipulated existing typefaces to create two of their own, which further enhance the feeling of whimsy generated by these posters.

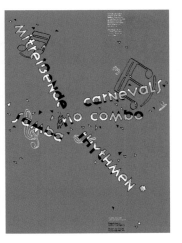
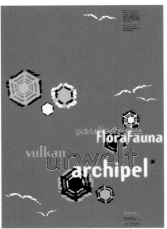
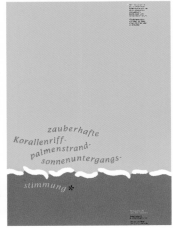
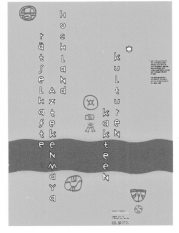

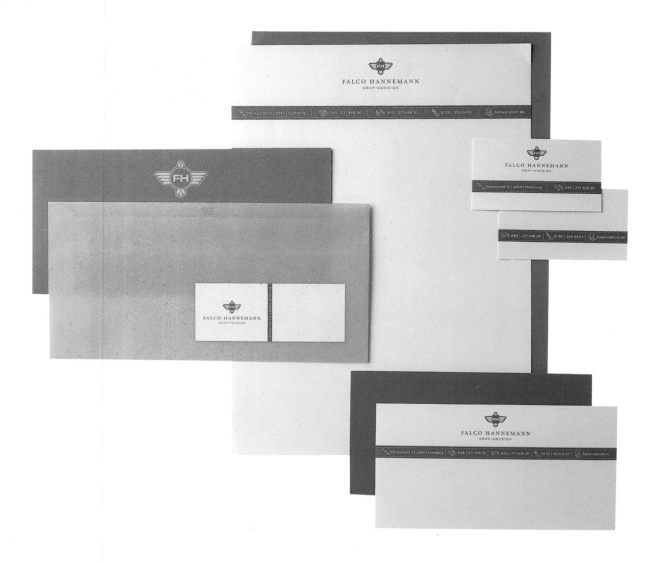

FALCO HANNEMANN GRAFIKDESIGN IDENTITY

Client Falco Hannemann Grafikdesign
Design Firm Falco Hannemann Grafikdesign
Designer Deborah Hon
Palette Orange / Gray

PROJECT DESCRIPTION
Falco Hannemann Grafikdesign needed a new identity that would communicate the personality of the firm and its style of design.

PROJECT CONCEPT
The primary objective was to take a modern, leading-edge color; mix it with a traditional, classic logo; and watch the sparks fly.

COLOR DESIGN
The unique combination of modern and traditional yielded an eye-catching design built around orange and as a secondary color, gray. This palette, combined with three typefaces—Trajan, Sackers, and Haashnica—makes an identity that says different yet established, forward-thinking yet results oriented.

LORAS COLLEGE VIEWBOOK

Loras College	Client
Get Smart Design Co.	Design Firm
Jeff MacFarlane	Art Director
Tom Culbertson	Designer
Jason Jones	Photographer
Olive Green / Sky Blue / Fire Engine Red / Loras Purple	Palette

PROJECT DESCRIPTION

Loras College is a liberal arts college, which was in need of a new viewbook to attract high school students. It had to be hip, youth-oriented, and definitely appear in no way to be like the traditional, stodgy college catalogs that inundate high school students as they prepare to select their college for the next four years.

PROJECT CONCEPT

Loras College knows what students want and in fact, outfits students with their own laptops, so appealing to the college-buying student is something they do well. The trick is to appeal to kids, while also appealing to their parents, who will ultimately foot the bill. To that end, designers relied heavily on colors to communicate and sell the college to prospective students.

COLOR DESIGN

Where did the palette come from? Designers had to go with Loras College's primary color—purple. But there was a secondary rationale, too. "We chose colors that students might find themselves wearing or driving," says Tom Culbertson. "Colors students are comfortable with that also complemented the school's color—purple."

To keep the feeling hip, innovative, and make the mailer stand apart from the competition, designers purchased static shield bags for use as mailing envelopes.

EVIL

Client	*Time* magazine
Design Firm	Mirko Ilić Corp.
Designer	Deborah Hon
Palette	Black on Black

PROJECT DESCRIPTION

Time magazine retained Mirko Ilic Corp. to illustrate its cover for an issue featuring an article about evil.

PROJECT CONCEPT

The colors chosen to answer this question were simply black on black.

COLOR DESIGN

Working with black is tricky, so the cover was executed two different ways for the domestic and international editions. The domestic cover was printed in two spot colors, whereas the international edition was printed in four-color process because it provided more consistency over multiple presses.

So powerful are the glossy black letters spelling *evil* on the matte black background that from newsstands the cover makes a powerful, emotional statement. Using black to represent evil is so timeless that even with a cursory glance this ominous cover can't help but evoke a gut-wrenching response. One immediately thinks the magazine cover is dated September 11, 2001, but it is not; the date on this cover is June 10, 1991.

POSTER FOR A MARILYN MONROE AUCTION

Christie's	Client
Parham Santana	Design Firm
Maruchi Santana	Creative Director
Deep Pink / Purple / Yellow / Red	Palette

PROJECT DESCRIPTION

Parham Santana was asked by American Movie Classics to create promotion materials for an auction to be aired exclusively on cable channels entitled "AMC Live from Christie's. The Personal Property of Marilyn Monroe."

PROJECT CONCEPT

Parham Santana wanted to create a poster that reflected the personality of Marilyn, her complexity, her timeless sexuality, and her ultimate, untimely death. It became a celebration of a woman who intrigues and inspires us to this day.

COLOR DESIGN

The color choice was based on a shocking pink Pucci dress that was owned by Marilyn. It was chosen because it was so full of life and intense color, just like the woman she was. The deep pink was very cosmetic, very female, and very sexy. The color, in addition, referenced the pop-ish, artificial colors of the 1950s and 1960s.

AFRICAN DENTIST IN AMERICA IDENTITY AND STATIONERY

Client Dr. Mark Stein
Design Firm Cross Colours
Creative Directors Joanina Pastoll / Janine Rech
Designer Janine Rech
Illustrator Chiara Rech (age 10)
Palette Magenta / Yellow / Orange / Green / Turquoise

PROJECT DESCRIPTION

Dr. Mark Stein, an African dentist practicing in the United States, wanted a corporate identity that bespoke his heritage.

PROJECT CONCEPT

"The theme of this stationery is African Dentist in America, therefore, the African mask was appropriate—with its mouthful of teeth—and, of course, all the vibrant colors of Africa were used in this illustration of the African mask," says Joanina Pastoll, co-creative director on the project.

COLOR DESIGN

Oil pastels were blended using a special technique from dark to light that the young illustrator, Chiara Rech, age 10, learned in her art classes. The artwork was then brought into Adobe Photoshop and was ultimately produced in Freehand. It was printed in four-color process on Rive Design paper.

ESPN X-GAMES

ESPN	Client
Cross Colours	Design Firm
Joanina Pastoll / Janine Rech	Creative Directors
Justin Wright	Designer
David Pastoll	Photographer
Red / Black	Palette

PROJECT DESCRIPTION

ESPN, the cable sports network, wanted a print campaign to promote the 2000 Summer X-Games, the *X* standing for extreme sports.

PROJECT CONCEPT

To demonstrate the extreme nature of ESPN's X-Games, "which sometimes verge on shocking, red and black were used aggressively," says Joanina Pastoll.

COLOR DESIGN

Dramatic, mood photography sets the stage for this print campaign, which was then colored in red and black—aggressive colors that played to the extreme headline "You're gonna die. So die trying." The color palette only seems to heighten the details in the vivid photography, which contributes equally to the message. The aggressive players don't seem to mind their battle scars, which drip black blood, so intent are they on their goal. This is not a print campaign that the casual reader glosses over.

BLUESQUARES.ORG

Client	Bluesquares.org
Design Firm	44 Phases
Designers	Yu Daniel Tsai / Luis Jaime / David Young / Pascal Wever / John Ottman / Kevin Ackerman / Fredi Buch / Leanna Fong / Daniel Garcia / Chalalai Haema / Huei Peng Lee / Staci Mackenzie / Armie Pasa / Prances Torres
Programmers	Michael Herf / Shawn Brenneman
Palette	Blue

PROJECT DESCRIPTION

In light of the tragic events of September 11, 2001, Bluesquares.org, a nonprofit Web site, was born. It was inspired by a group of artists—photographers, graphic designers, writer, and filmmakers, who felt a mixture of frustration and passion at not being able to show their support and empathy following the September 11 terrorist attacks. As a result of a series of conversations, meetings, and dashed e-mails, Bluesquares.org, a grass-roots initiative, came to be.

PROJECT CONCEPT

"A symbol helps signify how we feel," says Yu Daniel Tsai, one of the designers who worked on the project. "It connects us together for a common cause. We chose a square as an abstraction of the rectangular shapes of the two World Trade Center towers joined together. It also contains the shape of the Pentagon. Like the color blue of the United Nations and in the American flag, we chose blue to signify vigilance, perseverance, and justice—the primary tenets of peace anywhere."

COLOR DESIGN

The Web site was designed to be a living memorial to the events of September 11, 2001. Visitors are invited to add a blue square to the site and contribute words, well wishes, sentiments, or thoughts about this tragedy. Visitors are also encouraged to contribute a painting, a poem, drawing, or photography of something created as a result of September 11. These personal tributes add the occasional spot of color to a site otherwise colored entirely in blue.

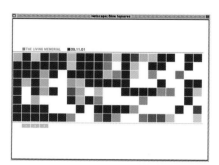
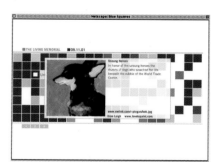
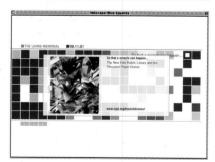

DALLAS SERVICES BROCHURES

Dallas Services	Client
Group Baronet	Design Firm
Meta Newhouse	Art Director
Gus Granger	Designer
Rex Curry	Photographer
Red / Green / Blue	Palette

PROJECT DESCRIPTION

Dallas Services, which offers day schooling, a low-vision clinic, and disability assistance, needed a family of brochures that spoke to each of its specialties.

PROJECT CONCEPT

"Dallas Services touches the people it works for in many ways, and the black-and-white photography enhances those emotions quite eloquently," says Gus Granger, designer. "With that being the case, we mirrored those feelings with a single bright color for each of the brochures, punctuating the personality of the organization as it is revealed in the three pieces."

COLOR DESIGN

Personalizing the brochures even more, are the handwritten messages about the person pictured on each cover. By accenting black-and-white photography with the colored, handwritten copy, the brochures hit home. They are simple, yet heartwarming. "This simplicity keeps the color from distracting from the images, while complementing the happiness at Dallas Services," adds Granger.

NOVELL 2001 BRAND CAMPAIGN

Client	Novell, Inc.
Design Firm	Hornall Anderson Design Works
Art Director	Jack Anderson / Larry Anderson
Designers	Jack Anderson / Larry Anderson / James Tee / Holly Craven / Michael Brugman / Kaye Farmer / Taka Suzuki / Jay Hilburn / Belinda Bowling
Photographer	David Emmite
Palette	Red / White

PROJECT DESCRIPTION

Novell, Inc., a networking software provider, called upon Hornall Anderson Design Works to help them elevate the Novell brand.

PROJECT CONCEPT

Designers accomplished this goal by taking ownership of the color red and the initial N from the pre-existing Novell wordmark.

COLOR DESIGN

"A generous use of white as a design element and red as a branding element was applied, as well as the contrasting use of bold colors," says Jack Anderson. "The red signifies power and strength, as well as longevity—all elements reflecting the client and their position in the software industry."

T26 ANYTIME NEWSPAPER

Client T26
Design Firm Segura Inc.
Art Director Carlos Segura
Designer Amisa Suthayalai
Illustrator Amisa Suthayalai
Palette Pink / Blue

PROJECT DESCRIPTION
Segura Inc. was given the job of developing a promotion for a new line of typefaces introduced by T26, a digital type foundry.

PROJECT CONCEPT
"For this piece, the colors blue and pink were chosen for their inherent connection with youth and gender," explains Carlos Segura. "The youthfulness of the colors helps to emphasize the newness of the fonts being introduced in the piece."

COLOR DESIGN
It's true. Blue and pink immediately conjure up images of new life and freshness. Here, they work well to introduce brand new typefaces. "The gender reference works with the title 'Anytime' and indicates that the fonts are for anytime and anyone," adds Segura.

**11:00 am
Sitting at a
square near
my office.**

**05:17 pm
Waiting for
6 o'clock.**

**07:00 pm
Walking to
a petshop
across the
street.**

**09:00 pm
Waiting
for a train
to come by.**

**11:00 pm
Talking to
my friend.**

KICKSOLOGY.NET IDENTITY SYSTEM

Client Kicksology.net
Design Firm Segura Inc.
Art Director Carlos Segura
Designer Amisa Suthayalai
Palette Orange / Brown

PROJECT DESCRIPTION

Kicksology.net, a Web-based portal that reviews basketball shoes, needed an identity system that was contemporary, yet paid homage to the game.

PROJECT CONCEPT

"What better color to utilize than basketball orange?" asks Carlos Segura of the design project for kicksology.net. "To complement orange, a brown was used, which both looks good and calls to mind the wood floored courts that are so much associated with the history of the sport."

COLOR DESIGN

The design was kept simple, minimal; the color choices are what drive the design, evoking nostalgia and the feel for the game. "These colors complement as well as offset the fresh and contemporary design by providing the company with a connection to the greater context of the sport," adds Segura.

RED CANOE IDENTITY SYSTEM AND PROMOTIONAL PIECES

Red Canoe	Client
Red Canoe	Design Firm
Deb Koch	Art Director
Caroline Kavanagh	Designer
Red / Yellow / Brown	Palette

PROJECT DESCRIPTION

"The design strategy of the Red Canoe brand began with the business name itself," explains Caroline Kavanagh, designer, "which evokes a vision of fun, simplicity, and color. A design cabin/studio in the woods above a river, Red Canoe incorporates both work and play into one existence, encompassing both the reality of the people behind the name and the classic escape fantasy of a relaxed, secluded lifestyle."

PROJECT CONCEPT

"The identity had to encompass and present these ideas to potential clients looking for an unconventional and fun, yet professional design firm. The canoe—a symbol of classic, simple, and timeless design—provided inspiration to the Red Canoe identity system," says Kavanagh.

COLOR DESIGN

The identity uses three warm colors—yellow, warm red, and brown—that are used consistently and boldly, but more as an accent color than as a primary palette. "The actual red canoe in the identity is carefully and consciously not overused, with more of a reliance on consistent type and color treatments to convey the Red Canoe identity," explains Kavanagh. "We wanted a bright and somewhat unconventional red that would add punch but not overpower. The warm red we chose supports the concept of old-time fun—think lollipops, tricycles, red wagons, slides, and mittens—evoked by the company's name and logo image.

"To take the theme further, a complementary yellow—bright, sunny—and brown—warm earth, textured wood, log cabins—works harmoniously together and highlights the quirky, classic retro hipness of innocent childhood summers spent in the woods and on rivers."

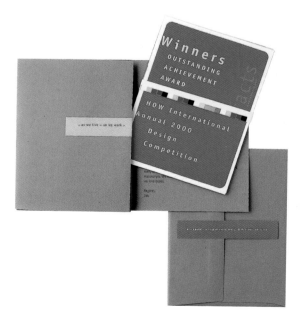

KATHOLISCHE KIRCHGEMEINDE SEMPACH

Client Katholische Kirchgemeinde Sempach
Design Firm Mix Pictures Grafik
Art Director Erich Brechbühl
Designer Erich Brechbühl
Palette Yellow / Black

PROJECT DESCRIPTION

A Catholic church in Switzerland was in need of a letterhead system that aptly reflected its ministry.

PROJECT CONCEPT

Designer Erich Brechbühl used die-cutting and color to set this identity system apart. Printing on the front of the identity is kept minimal—only the church's name appears in black. This is augmented with six die-cuts to simulate church windows.

COLOR DESIGN

The reverse of the letterhead is flood printed with yellow so that when the letter is folded, the yellow shows through the die-cuts—like the "warm light inside the church," says Brechbühl.

RUSSIAN THEATER SATURDAY

Theater Saturday	Client
Misha Design Studio	Design Firm
Misha Lenn	Art Director
Misha Lenn	Designer
Anatoly Richagov	Photographer
Yellow / Black	Palette

PROJECT DESCRIPTION

Theater Saturday, a semiofficial theater in communist-dominated St. Petersburg, Russia, asked designer Misha Lenn to create a logo that spoke to the community and communicated that entertainment is something to be enjoyed.

PROJECT CONCEPT

Using a minimalist palette of yellow and black, Lenn integrated a photo of hands into the foreground of the design and rendered this element in black. The hands hold what looks to be sunshine, which emanates from the burst of yellow he placed in the center of the artwork.

COLOR DESIGN

"The color emphasized the creation of hope and joy from the black-and-white daily background," says Lenn, citing how the logo, like the theater itself, works to bring some lightheartedness, joy, and diversion to the challenges of daily life.

Color and Kids

Although most adults see pastels as appropriate choices for infants, studies show that tiny tots are most drawn to vibrant primaries of red, blue, and yellow. Between the ages of three to six, their attention is drawn to the secondary shades of green, purple, and especially orange. This age group is also drawn to sparkling, shimmery finishes and if it sparkles in bright colors, all the better.

There is a new phenomenon that started in the 1990s. Beginning at the toddler stage was the introduction of black and deepened Euro colors, which was always verboten in kid's markets. And these sophisticated colors are even more prevalent in the tween market of ages six to twelve.

This is not to suggest that brights have lost their appeal for kids. They are still powerful attractors in all graphic applications such as ads, Web sites, packaging, TV commercials, and video games.

Of course, the operative word is cool. Kids at this tween stage want desperately to fit in—to look like their peers and to wear and carry the colors that their friends do. They study very closely what they see on display in malls. As part of this need to look just like their friends, brand image becomes very important because they can then be sure they will fit in.

This is also the age when they want things that seem disgusting to their parents. Sickly yellow green (the color of squished caterpillar) is especially appealing. If there was a green hot dog available to kids, that's the one they'd want to eat! For these younger age groups, the color of food is actually more important than the taste. Kids also have great visual acuity and will notice subtle differences in color more rapidly than adults.

There are less hard and fast gender identification rules about color today. At one point, all pinks were strictly for girls. Currently, the brighter hot pinks work across both genders and are often used to denote active sports. Another color that was considered strictly feminine was purple. But as a result of its use in active sports, especially in sports logos, purple is now well accepted by male tweens and teens.

Tweens are rehearsing for their teenage years. At ages ten to twelve, they study teenagers very closely for the next big trend. For example, if black is the hot teen color, that's what the older tweens want, so it behooves the graphic designer working with these youth markets to stay on top of the trends.

SARDINIA POSTER AND INVITATION

Client	Paul Elledge Photography
Design Firm	Lowercase, Inc.
Art Director	Tim Bruce
Designer	Tim Bruce
Photographer	Paul Elledge
Palette	Black / Dark Orange

PROJECT DESCRIPTION
Photographer Paul Elledge sought the expertise of Lowercase, Inc. when he needed an invitation and poster to promote an exhibition of his works.

PROJECT CONCEPT
Elledge's work—as shown here—is part of his Fotografie Italiane collection called Sardinia. The photos were all taken recently, but rendered in sepia tones to make them look like oft-thumbed vintage photographs of the locals from an Italian village.

COLOR DESIGN
"The use of color in the photo tritones is meant to invoke a sense of classic Italian photography," says Tim Bruce, art director and designer on the project. As a whole, the package does more than that; the color palette lends a richness and elegance to the pieces, along with a certain reverence for the past.

EKH DESIGN CHRISTMAS CARD

EKH Design	Client
EKH Design	Design Firm
Myriam Kin-Yell	Art Director
Sandra Marta	Designer
Sinead Doyle	Photographer
Lime Green / Fuchsia / Orange / Black / Turquoise	Palette

PROJECT DESCRIPTION

Like most graphic design firms, EKH Design wanted to create its own Christmas card for the upcoming holidays but, unlike a majority of design firms, it is located in Sydney, Australia, where Christmas occurs in the summertime, necessitating a different color palette than is considered traditional.

PROJECT CONCEPT

"As Christmas in Australia is in summer, bright colors have been selected to enhance this summer festive season," says Anna Eymout of EKH Design. As a result, instead of a palette of cool wintry whites and icy blues or traditional pine green and red, the card takes a completely different tact.

COLOR DESIGN

"Designers took to the beaches and streets of Sydney with a digital camera and a determination to capture their own experience of Christmas in the beautiful city," says Eymount. The result is an eclectic mix of traditional holiday icons—Rudolph the Red-Nosed Reindeer—alongside "Aussie Snow," which is a shimmering ocean beach.

The promotion drives home more than a holiday message; it proves that the adage "know your audience" should never be shrugged off—the power of color to evoke a response will vary from market to market.

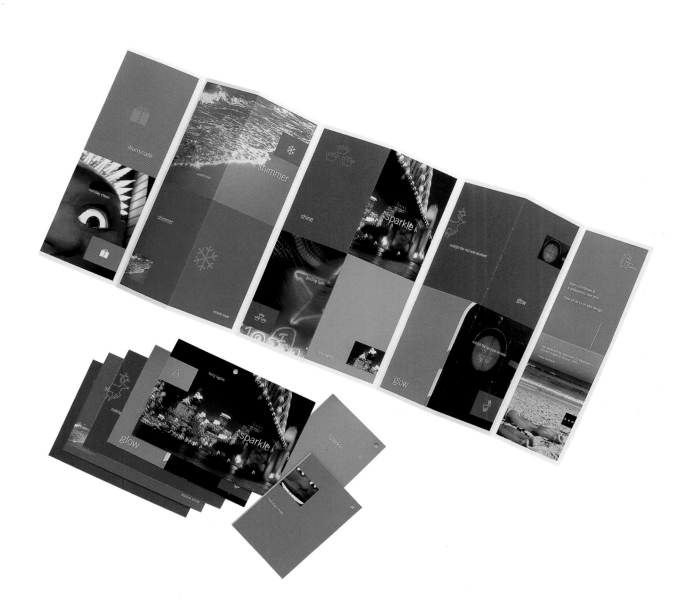

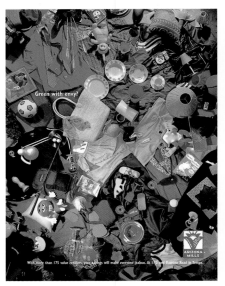 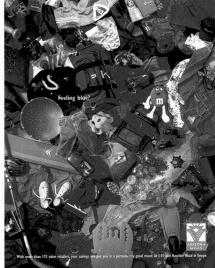 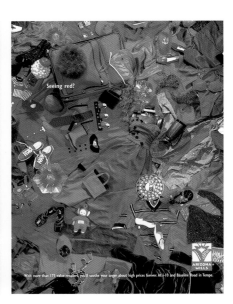

ARIZONA MILLS ADVERTISING SERIES

Client Arizona Mills
Design Firm After Hours Creative
Palette Red / Blue / Green

PROJECT DESCRIPTION
Arizona Mills, a shopping mall with more than 175 retailers, needed an ad campaign that adequately represented all of its stores and their diversity.

PROJECT CONCEPT
After Hours Creative developed an idea based around a series of three ads—each of which would be created in a single color, since colors are often associated with moods—especially moods that tend to spur shopping sprees.

COLOR DESIGN
"Once we found a way to unite a certain kind of mood with a reason to shop at Arizona Mills, we went to all the retailers, asked for products in that color, assembled them into a giant collection, and took the shot," says Russ Haan. "The result was a striking and simple series of ads that conveyed the breadth of the items available at the mall and reinforced their value, shopping, and entertainment positioning."

VENT HOLIDAY POSTERS

Vent Client
After Hours Creative Design Firm
Red / Green Palette

PROJECT DESCRIPTION

Unsettling is an understatement to describe this series of three posters that extend Season's Greetings, wish Happy Holidays, and promote Peace on Earth, while using old Marine training handbooks along with traditional holiday colors to provoke a response.

PROJECT CONCEPT

"Holiday colors are red and green. But when you use really bright versions, contrast them with black illustrations from military manuals, you get a troubling contrast," says Russ Haan, After Hours Creative.

COLOR DESIGN

"We took the irony of holidays based on religion with the fact that most wars are caused because of religious differences. The contrast of the happy greetings with the violent images summarizes the global predicament we're in now," adds Haan. "The in-your-face colors grab your attention even before you read the message."

IPT2000

STOP POSTER

Client — Penn State Institute for Arts and Humanistic Studies
Design Firm — Sommese Design
Art Director — Lanny Sommese
Designer — Lanny Sommese
Illustrator — Lanny Sommese
Palette — Black / Red

PROJECT DESCRIPTION

Sommese Design was brought aboard to create a poster to promote gun control. Subsequently, what had originally been an idea Lanny Sommese created as a contest entry was finessed and re-created as a poster that is startling in its simplicity.

PROJECT CONCEPT

Lanny Sommese used red, which metaphorically calls to mind fire, stop signs, danger, and blood in the design as a subtle spot color. "Because of the topic, it was a no-brainer to use red," Sommese says.

COLOR DESIGN

He added the red with spray paint. Then, he scanned the artwork into the computer. "The sprayed effect enhanced the message by giving a raw human look to the image. The spray painted look also added to the image emotionally and added another level of metaphor," says Sommese.

HERMAN MILLER 1998 ANNUAL REPORT

Herman Miller	Client
BBK Studio	Design Firm
Yang Kim, Steve Frykholm (Herman Miller)	Art Directors
Yang Kim	Designer
Steven Joswick / Yang Kim	Illustrator
Orange / Red / Green / Blue / Yellow / Pink	Palette

PROJECT DESCRIPTION

Furniture manufacturer Herman Miller was commemorating its 75th anniversary, so when the time came for its annual report, designers decided to dub the event a birthday and followed through on the theme from there.

PROJECT CONCEPT

"We wanted to have a party with the book," remembers Yang Kim, art director and designer on the project. "We chose primary colors and had fun with party favors like confetti, pop-ups, a party hat, megaphone, balloon, and a button."

When used on their own, primary colors have their own unique personalities. When combined, as they are here, they generate a lighthearted, party atmosphere. They communicate a fun, playful, boisterous, and carefree attitude.

COLOR DESIGN

The art for the party hat was created with all the names of Herman Miller's employees—about six thousand at the time—with multicolored stars separating each name. This particular aspect of the project was tedious and time-consuming, but by making the star into a font keying in the names became a much more efficient process.

A great year, a great history, a great future.
1998 Annual Report Herman Miller, Inc., and Subsidiaries

HAPPY 75TH BIRTHDAY
HERMAN MILLER!

THE DAY LIBERTY CRIED POSTER

Client	New York City Technical College
Design Firm	New York City Technical College's Image/Visual Communications Department
Art Director	Dominick Sarica
Designer	Priska Diaz
Illustrator	Priska Diaz
Palette	Blue / Red / Light Green

PROJECT DESCRIPTION

Following the events of September 11, 2001, the New York City Technical College, which is located across the Brooklyn Bridge from the World Trade Center Towers, retained Dominick Sarica and Priska Diaz to visually interpret the mood of the city and, indeed, the world.

PROJECT CONCEPT

"The Day Liberty Cried" borrows many of the graphic elements that have been used in other promotional posters for the New York City Technical College, including the Brooklyn Bridge—demonstrating its proximity to Manhattan and the New York City skyline. The difference with this particular rendition is that now the skyline is ominously devoid of its two tallest landmarks.

COLOR DESIGN

"The use of strong but sober colors is predominant to strengthen the seriousness of the theme, and it brings drama to the subject matter," say Sarica and Diaz. "The subliminal use of the U.S. flag's colors becomes the sky."

COMMONWEALTH BANK OF AUSTRALIA CORPORATE IDENTITY

Commonwealth Bank of Australia	Client
Cato Purnell Partners Pty. Limited	Design Firm
Yellow / Black	Palette

PROJECT DESCRIPTION

Cato Purnell Partners welcomed the chance to develop the corporate identity for Commonwealth Bank of Australia, which wanted an identity it could own.

PROJECT CONCEPT

"The color category for this identity should really be ownership of a color for marketing purposes," say designers at Cato Purnell Partners of the easily recognizable yellow icon they developed for Commonwealth Bank. The modern, abstract shape of the icon and its distinctive yellow color are recognized in Australia much the way that the Kodak yellow brand is recognized worldwide. In fact, the two have become inseparable—yellow and Commonwealth Bank.

"The Commonwealth Bank is so protective of its particular color yellow that it has registered it legally the same way that a trademark is registered for copyright," say the designers.

COLOR DESIGN

The yellow block appears most often against a black background where the contrast is startling. When it appears against a white background, a small area of black enhances the brightness of the yellow for added contrast.

NEOCON COLORS WEB SITE

Client	Herman Miller
Design Firm	BBK Studio
Art Director	Kevin Budelmann
Designer	Mike Carnevale
Palette	Black / Red / Blue / White / Green

PROJECT DESCRIPTION

In conjunction with the launch of a NeoCon (a contract furniture trade show) promotional site for Herman Miller, BBK Studio developed an online version of the company's "Things That Matter" campaign.

PROJECT CONCEPT

The digital version of the campaign was created in a sophisticated, gamelike format where DHTML layers and JavaScript are used to allow users to reveal marketing messages with an element of surprise.

COLOR DESIGN

The game is presented in a color palette that plays off thematic statements and serves as the site's navigation. Squares of black, red, blue, white, and green act as the navigational bar, but there's more. Each color gets its own screen that makes a statement about the color, which then leads into statements about Herman Miller. For instance, the green screen states, "After 75 years, we're still green," then goes on to tout Herman Miller's commitment to environmentally sensitive products and business practices.

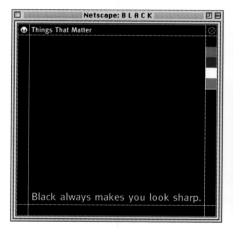

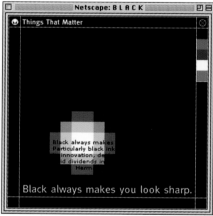

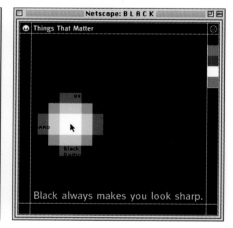

Another red-letter year.

WINE

BRICK

After 75 years, we're still green.

THUMB
PEACE
HORNET
GRASS
TEA
HOUSE Herman Miller digs green things.

THUMB
PEACE
PEAR
HORNET
BAY
GRASS
TEA

Over 75 years in the furniture business, we're still green. The General Services Administration just gave us their Green Award for environmentally sensitive products and business practices.

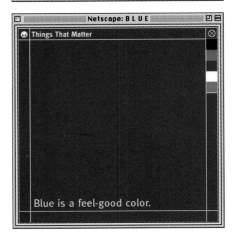

Blue is a feel-good color.

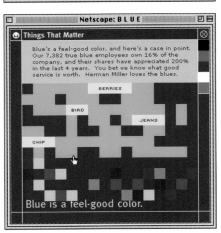

Blue's a feel-good color, and here's a case in point. Our 7,382 true blue employees own 16% of the company, and their shares have appreciated 200% in the last 4 years. You bet we know what good service is worth. Herman Miller loves the blues.

BERRIES
BIRD
JEANS
CHIP

Blue is a feel-good color.

INDUSTRY FILMS HOLIDAY CARD

Client	Industry Films
Design Firm	Blok Design
art director	Vanessa Eckstein
Designer	Stephanie Yung
Palette	White / Orange

PROJECT DESCRIPTION

"Create a holiday greeting card for us," was the dictate from Industry Films. Blok Design gladly took on the project and opted to do something nontraditional.

PROJECT CONCEPT

Holiday cards are traditionally dressed in red and green but not this one. There are no embellishments here. This card is simply white on white blind-embossed; the only color is just a touch (a small touch) of orange—which signifies hope. "This holiday card was about giving and caring," says Vanessa Eckstein, art director. "We felt that blind-embossing the type was a way of connecting to the text—of actually feeling the message."

COLOR DESIGN

"There is a honest and simple approach about simple white-on-white typography," says Eckstein of the blind embossing, which does give the recipient a way to feel the message and be touched by its content. Its understatement is due largely to the white-on-white palette, which aptly demonstrates the power of color or lack thereof.

IT'S ABOUT A CURE. ON YOUR BEHALF WE MADE A DONATION TO THE AIDS COMMITTEE OF TORONTO AND TO THE BREAST CANCER SOCIETY OF CANADA. HAPPY HOLIDAYS + OUR BEST WISHES FOR 2001. FROM ALL OF US AT INDUSTRY FILMS.

LEATHERMAN TOOLS 2001 CATALOG

Leatherman Tool Group	Client
Hornall Anderson Design Works	Design Firm
Jack Anderson / Lisa Cerveny	Art Directors
Lisa Cerveny / Andrew Smith / Andrew Wicklund / Don Stayner	Designers
Jeff Condit / Studio 3	Photographers
Black / Orange	Palette

PROJECT DESCRIPTION

Hornall Anderson Design Works has developed promotional materials for the Leatherman Tool Group for years. In this case, the firm was asked to develop Leatherman Tools new product catalog of sleek, upscale tools.

PROJECT CONCEPT

"Black was used as the primary color on the cover of the catalog to express a sexy feel to the tools, mingled with the industrial idea of their purpose," says Jack Anderson. Black was combined with a color picked up from one of the actual tools—a golden orange. Instead of looking too much like Halloween, this color combination says, "I'm different!"

COLOR DESIGN

According to Hornall Anderson, the color black "gives the tools a look of more than just another tool, but rather something one can carry with them on a regular basis to be used for a multitude of purposes in their daily experiences. It reflects the 'go anywhere, do anything' idea that the Leatherman philosophy is based upon. Sleek, yet tough."

XOW! IDENTITY PROGRAM

Client	XOW!
Design Firm	Hornall Anderson Design Works
Art Director	Jack Anderson / Lisa Cerveny
Designer	Lisa Cerveny / Bruce Branson-Meyer / Mary Chin Hutchison / Jana Nishi / Don Stayner
Photographer	Anthony Nex (flyer)
Palette	Blue / Yellow / Orange / Green

PROJECT DESCRIPTION

XOW!, art learning centers for children, wanted an identity program that used bright and bold colors to draw attention from both children and their parents, while reflecting the playful and creative aspect of animation and art.

PROJECT CONCEPT

Designers were attuned to the client's wishes for bright and bold colors but, nevertheless, they were careful to avoid the design using too many Crayola-like colors because they didn't want the program to appear too childlike.

COLOR DESIGN

"Initially, designers did employ a palette of primary colors, but ultimately, they chose a more sophisticated palette of muted blue, yellow, orange, and green. The idea was to combine elements of play and fun alongside education and animation/motion while appearing sophisticated since it was important that XOW! be perceived as a serious business."

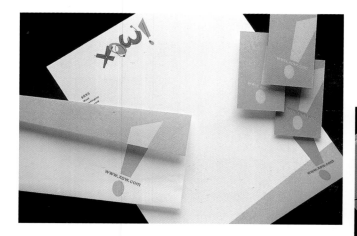

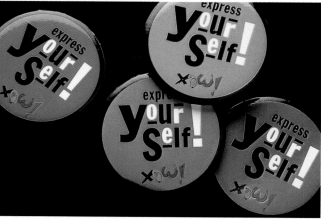

CENTRAL PENNSYLVANIA FESTIVAL OF THE ARTS CALL FOR ENTRIES

Central Pennsylvania Festival of the Arts	Client
Sommese Design	Design Firm
Lanny Sommese	Art Directors
Erik Boissonneault / Marc Elias	Designers
Lanny Sommese	Illustrator
Orange / Yellow / Green / Black	Palette

PROJECT DESCRIPTION

Sommese Design has created the promotions for the Central Pennsylvania Festival of the Arts, an annual midsummer celebration of the visual and performing arts, for thirty years. The campaign begins with a poster that captures the look and feel of the event, which is followed by a series of call for entry brochures, T-shirts, and more.

PROJECT CONCEPT

Since the festival is held on the Penn State University campus and in State College, a city nestled in the mountains of central Pennsylvania, Lanny Sommese decided to replicate the landscape in an abstract fashion on the call for entries brochures. Green was chosen for the natural setting and bright yellow for the summer sun. The colors were kept bright to reflect the party atmosphere of the event. Black was added to make the colors appear even more intense and vivacious.

COLOR DESIGN

Sommese used an airbrush effect to feather and blend colors to create a glow. "Color is important as well to enhance the collectibility of the poster," says Sommese. "The festival goers seem to like colorful and are more likely to take a colorful poster home."

JAN COLLIER REPRESENTS IDENTITY SYSTEM

Client — Jan Collier Represents
Design Firm — Red Canoe
Art Director — Deb Koch
Designer — Caroline Kavanagh
Palette — Yellow / Red / Brown / Green

PROJECT DESCRIPTION

"Jan Collier Represents, an artists' representative of freelance commercial illustrators, was ready for a redesign," says Deb Koch. The redesign was done so that Collier would stand apart form the competition, yet the design couldn't be so radical that it wouldn't complement the illustrations she represents or overpower those works.

PROJECT CONCEPT

"The identity system utilized color, typography, and words—all in a slightly offbeat odd size, daring, and bold manner, while maintaining the elegance that is also Jan Collier Represents. The design in full communicates meaningfully about the specific firm, the industry, and the people who are Jan Collier Represents—their nature, their personalities, and interest—that which stands for what is behind the company and for what stands before the company," adds Koch.

COLOR DESIGN

"The choice and use of color in this identity system is very personal and specific to both Jan Collier Represents and its field of illustration," says Koch. Because the system had to complement various styles of illustration, it had to be flexible to mood, tone, and communication style. With that in mind, designers chose a palette of three main colors—yellow for uplifting and spiritual, dusty green for grounding, quiet, and comforting, and a bold red for courage, fire, and passion—that would work as well together or separately.

THEATRICAL POSTER FOR "TYPHOID MARY"

Jugendtheatre Willisau(Youth Theatre Willisau)	Client
Niklaus Troxler Design	Design Firm
Niklaus Troxler	Creative Director
Red / Purple	Palette

PROJECT DESCRIPTION

Niklaus Troxler was asked to create a promotional poster for a theatrical rendition of "Typhoid Mary."

PROJECT CONCEPT

Niklaus wanted to capture the grim theme of Typhoid Mary in his poster. Because the horror of Mary is that everyone whom she cooked for died, he felt that a portrayal should induce feelings of danger and fear.

COLOR DESIGN

Troxler wanted to "visualize the virus in his design." He worked with a brush and wet ink using a free-flowing, ink drip style to create the image and lettering for the piece. This gave it a look of random disorder and chaos, which became reinforced by his strong color choices of morbid red and ghoulish purple.

Jazz Blvd. Niklaus Troxler Posters / Lars Müller Publishers

JAZZ BLVD BOOK COVER AND POSTER

Client Niklaus Troxler Design
Design Firm Niklaus Troxler Design
Creative Director Niklaus Troxler
Palette Lime Green / Magenta / Purple

PROJECT DESCRIPTION

The project involved the creation of a book
cover for a book of jazz posters designed by
Troxler himself. The original design was a
poster, of which various parts were used to
create eight different versions for the book.
The poster was also for sale.

PROJECT CONCEPT

Niklaus Troxler's passion for both jazz and
design resulted in the creation of a jazz
festival in his hometown of Willesau,
Switzerland. Consistent with the
underlying theme of the book, Troxler
created the piece as a response to the
colorfulness of sound. He used color line
and shape to express jazz music.

COLOR DESIGN

Troxler's images stemmed from the sound
of the music, the motions of the musi-
cians, and the style of the instruments.
Active lines and shapes are supported by
his strong color visualization. In Jazz Blvd
he has used his intuitive color sensibility to
evoke excitement, create contrast, and
heighten the activity of the piece. "Color,"
he says, "brings the design to a point."

PROTOTYPE FOR THE REDESIGN OF WEST MARINE

West Marine Client
Design Forum Design Firm
Bill Chidley Creative Director
Blues / Yellows Palette

PROJECT DESCRIPION

Bill Chidley's team at Design Forum wanted to create a lifestyle statement with the redesign of the West Marine store chain. The redesign project included everything from fixtures through signage and wall and floor graphics.

PROJECT CONCEPT

The concept behind the redesign of West Marine was to immerse the shopper into a lifestyle experience. References to the boating world were made in everything from floor graphics to boat murals to fixtures made to include boat and dock elements. The boating lifestyle merchandise was easy to work around in that a strong design would not interfere, rather it would enhance the overall theme.

COLOR DESIGN

Although a primary color scheme was used, blue was the most significant color throughout the store. Many of the wall and fixture graphics were done in a sea mist blue, with ship images superimposed on them. The blue graphics and white and chrome fixtures contrasted with the intense yellow and red signage. The intensity of these accent colors not only increased legibility and focus, but reinforced the boating world theme with their brightness. The merchandise itself, such as rain gear and ropes, in yellows, reds, blues, and other highly intense colors, enhanced the primary scheme.

PROMOTIONAL PIECE FOR DMX MUSIC

Client	DMX Music
Design Firm	KBDA
Designer	Jamie Diersing
Palette	Red / Cool Gray Green / Blue

PROJECT DESCRIPTION

DMX, a company that offers commercial free programmed music, worked in conjunction with KBDA on a promotional piece to send to companies in advance of a sales call or to leave behind.

PROJECT CONCEPT

The purpose was to create a piece that had a lot of energy and vibrancy. The tagline, "Are you listening?" in big blocky design was just one of the attention-getting design techniques in the piece. The design was created as a flipbook to increase movement with a clean, bright color palette.

COLOR DESIGN

The clear, intense color palette heightens the dramatic design presentation. The red and black of the logo were used in addition to green, blue, and orange to evoke the high energy and excitement of the music world.

POSTER FOR A CLOCKWORK ORANGE

Sensurround Staging	Client
Ames Design	Design Firm
Barry Ament	Creative Director
Red / Neon Orange / Black	Palette

PROJECT DESCRIPTION

Ames design was asked to create a play poster for the first theatrical production of *A Clockwork Orange*.

PROJECT CONCEPT

Although the director/producer didn't want associations to be made with the movie or its imagery, they did want an ultraviolent approach to the design of the piece. As a response to this, Barry Ament of Ames Design created a very subtle, violent character as a focal point. A pencil sketch was used for final art to enhance the rawness of the piece.

COLOR DESIGN

To keep the "underground effect," Ament used two colors that he considered to be a bold and somewhat dissonant color combination. Neon orange and black created almost a nauseating effect, but he still kept black and red, a historically violent color combination.

POSTER FOR *NEW PATAGONIA*

Client Seattle Repertory Theatre
Design Firm Ames Design
Creative Director Barry Ament
Palette Lime Yellow / Black / White / Green / Blues / Pinks / Oranges

PROJECT DESCRIPTION

Ames Design was asked by Seattle Repertory Theatre to create a poster for a production of *New Patagonia*.

PROJECT CONCEPT

The play was a one-man show that told the story of a Timothy Leary–type character looking back on his days of sex, drugs, and rock 'n' roll. For the poster, Ament used a Fillmore style (1960s poster designed for rock shows at a venue called the Fillmore) to create an instant association with the summer of love. By graphically placing the type and images inside of the character's head, Ament created an image that portrayed a man looking back on his life.

COLOR DESIGN

The colors were chosen to strengthen the 1960s imagery. He used the split fountain technique, common in the 1960s, in which several colors are pulled at the same time, rather than individually causing the colors to bleed together in a rainbow type effect.

CD COVER FOR JESTER'S *DIGITALIA*

Pulse Records	Client
F3	Design Firm
Stephen Jensen	Art Director
Stephen Jensen	Designer
Jimmy Z	Model Photographer
Green / Chrome / Black	Palette

PROJECT DESCRIPTION

F3 was asked by Pulse Records to create a CD cover for *Digitalia* by Jester, a melodic hard rock band.

PROJECT CONCEPT

The music was created to function as an auditory version of cybersex. The design featured a nude woman bound and hidden by cyber-circuitry for skin. The band wanted the figure abstracted so the viewer would have to search for it. After several versions F3 designed an abstracted version of the figure covered by digital pathways, using a silver belly ring as the identifying physical feature.

COLOR DESIGN

Green, black, and white created a limited palette for the cover. Rather than choosing colors based on popularity, Stephen Jensen used green as a reference to electricity and as a techno-1980s association.

JASON BAILEY HAS DISCOVERED
THE SECRET OF IMMORTALITY...
AND THE CURE FOR IT.

BLOODLUST POSTER

Client	Independent Filmmaker
Design Firm	F3
Art Director	Stephen Jensen
Designer	Stephen Jensen
Palette	Deep Red / Fleshtone

PROJECT DESCRIPTION

Stephen Jenson of F3 design was asked by an independent filmmaker to create a promotional poster for a yet-to-be released horror flick.

PROJECT CONCEPT

The idea was to create a feeling of blood and lust stemming from the movie title *Bloodlust*. The bark is made to look like flesh and the water is made to look like blood creating an evil and vampirish mood.

COLOR DESIGN

The water was changed to red over blue to create a feeling of overflowing and dripping blood and gore but not necessarily violence. The milky color of the bark torn off the tree was used to resemble aged, wrinkly flesh.

FRENCH AIRLINE IDENTITY PROGRAM

Air Littoral	Client
Metzler and Associates	Design Firm
Marc Antoine Herrmann	Creative Director
Jespwer von Wielding / Per Masden / Jerome Dam / Marie Laporte	Designers
Red / Blue / Yellow	Palette

PROJECT DESCRIPTION

Air Littoral, a small airline that operates in the south of France, came to Paris-based Metzler and Associates to create a new identity system, to include stationery and collateral material. In addition, plane graphics, dishes, and uniforms were coordinated.

PROJECT CONCEPT

Metzler and Associates' concept was to give the company a strong regional association with the south of France. Southern French visual elements were used with bright colors to give a more Matisse-like feeling combined with regional values including "welcome, warmth, a moment in the sun." The company developed strong ties to the southern manufacturers using local products on board.

COLOR DESIGN

The bright, warm color palette reinforced the warmth and inviting qualities of the south of France. The colors create the identity and the association.

RSN BRAND VISION BOOK

Client | RSN, Inc.
Design Firm | The VIA Group
Art Director | Bonnie Hamalainen
Designers | Steve LaChance / Travis Goulder
Copywriter | Christina Dalessio
Palette | Primary: Orange / Blue / Green / Aqua / Secondary: Bright Yellow / Deep Purple / Red Brown

PROJECT DESCRIPTION

VIA was asked to create the RSN vision book as one part of a comprehensive brand identity system that they developed for RSN Inc, a media company producing television and Web services for outdoor enthusiasts. The brand identity system consisted of two primary pieces: the brand vision book and a brand identity manual.

PROJECT CONCEPT

The brand vision book was an internal education piece aimed to explain products, services, and target audience to employees. The visual content describes RSN's primary brand attributes of inspiration, rejuvenation, approachability, authenticity, immediacy, and fun. The horizontal format and directive subheads to "open the door, be yourself," reiterate an ongoing active story.

COLOR DESIGN

A highly saturated color palette creates a fresh, intentional, and active color system. Large expressive color fields play off of related photographic imagery for emotive impact. The horizontal color fields move the viewer through the book. Different combinations of color loosely reference seasonal color temperatures such as "the coolness of winter, the freshness of spring, and the warmth of autumn."

CHELA FINANCIAL AND CORPORATE REPORT

Chela	Client
Kirshenbaum Communications	Design Firm
Susan Kirshenbaum	Creative Director
Jim Neczypor	Designer
Doug Ross	Illustrator
Lessley Berry	Copywriter
Yellow / Gold	Palette

PROJECT DESCRIPTION

Chela, the United States' largest nonprofit institution focused solely on education finance, asked Kirshenbaum Communications to create a financial and corporate report that would be targeted at financial institutions, government agencies, and financial aid administrators.

PROJECT CONCEPT

The report is based on the idea of connections. The mission statement for the nonprofit is to finance lifelong education while strengthening the bonds between the learner, the school, and the lenders. The cover illustration was based on literally connecting the dots from school to financial institutions with the money in between.

COLOR DESIGN

The key color for the report was yellow, which represents the pencils students use, the color of a school bus, and the gold connecting students and their financing. In addition, the yellow brick road is used to show a path of growth and exploration. Because they are targeting an older age group, Kirshenbaum decided against other primaries in favor of a more sophisticated and subdued, but lively and colorful, color scheme.

Reaching Out
to Create Lives Full of Learning

ENCOURAGING RESPONSIBLE BORROWING
In 1999, our AcademicEdge scholarship program awarded $50,000 in grants based on essays in which students described how responsible borrowing is helping them to reach their education goals. A team of Bay Area financial aid administrators and Chela Financial staff judged essays from over 1,200 entrants, finally selecting ten students to receive awards of $5,000 each.

EXPANDING OPPORTUNITY BY INCREASING AVAILABILITY
With the cost of higher education rising, our commitment to meeting students' financial requirements includes loan and scholarship programs designed both to provide greater flexibility in terms of education options and to promote responsible borrowing. AcademicEdge℠, introduced in April 1999, is a case in point. These credit-based consumer education loans augment government-backed funding to provide the additional funds students need. Flexible interest rate terms reward young borrowers who maintain a strong credit rating—a compelling incentive for learning the principles of responsible credit management.

WORKING TOGETHER TO BROADEN THE OPTIONS
Through teamwork, we are able to provide more students with more possibilities. Our CalEdge℠ loan program is a unique effort that fills the need for generous loan amounts at low fixed rates for smart students who prefer the predictability of this option. Funded directly by the California Educational Facilities Authority (CEFA), a department of the State Treasurer's Office, and made available through over 35 participating California schools, the loans are originated and administered by Chela Financial USA, Inc. On the repayment side, we design many of our loan programs to offer borrower benefits that reward responsible borrowing. R¹ Rate Reduction℠ lightens the interest burden for students who make payments through electronic withdrawals, while our R and R Rates for the Reliable℠ programs significantly reduces rates for borrowers with on-time payment records.

INSPIRING LEARNING WITH SCHOLARSHIPS
Financial incentives can foster ambitions, encourage achievement, and make the difference between dreams and diplomas. With that in mind, the Chela Financial Scholarship Program has awarded over $1.5 million in funds since its inception in 1996. Our year 2000 program will add another $500,000 to the total. About half of the awards to date have gone directly to deserving students who are nominated by their financial aid administrators. Other funds have been disseminated through community organizations and foundations that encourage higher education and know their constituents' needs.

INVESTING IN YOUTH TO INFLUENCE THE FUTURE
Thoughts of the future start early and ideas nourished in youth can have a powerful influence on adult decisions. To stimulate young minds, our "I'm Going to College" early awareness program gives fourth- and fifth-graders an opportunity to experience college life. Events in 1999 took students on day-long campus tours in San Francisco, California, and Tacoma, Washington. We are also participating in the federal GEAR UP program to track the college preparedness of students from middle school through high school graduation. As a part of our participation, we committed $75,000 in GEAR UP scholarships for students who successfully complete this program. These efforts underscore the nonprofit focus of our company and illustrate our commitment to encourage and enable students seeking higher education.

Directory

Addison
20 Exchange Place
New York, NY 10005
www.addison.com

After Hours Creative
5444 E. Washington, Suite 3
Phoenix, AZ 85034
www.ahcreative.com

Ames Design
518 Green Lake Way N
Seattle, WA 98103
www.amesdesign.com

BBK Studio
648 Monroe Avenue, NW, Suite 212
Grand Rapids, MI 49503
www.bbkstudio.com

Barbara Brown Marketing & Design
2873 Pierpont Boulevard
Ventura, CA 93001
bbrown@bbmd-inc.com

Blok Design Inc.
822 Richmond Street West, Suite 301
Toronto, ON M6J 1C9
Canada

Braue Branding & Corporate Design
Eiswerkestrasse 8
27572 Bremerhaven
Germany
www.brauedesign.com

Büro für Gestaltung
Domstrasse 81
D-63067 Offenbach
Germany
www.bfg-im-netz.de

Cahan and Associates
171 2nd Street, 5th Floor
San Francisco, CA 94105
www.cahanassociates.com

Cato Purnell Partners Pty. Limited
254 Swan Street
Richmond, Victoria 3121
Australia
www.cato.com.au

Crawford/Mikus Design Inc
887 W. Marietta Street NW, Suite T-101
Atlanta, GA 30318
www.crawfordmikus.co

Cross Colours
P.O. Box 47098
Parklands, 2121
South Africa
www.crosscolours.co.za

Design Forum
7575 Paragon Road
Dayton, OH 45419
www.designforum.com

Dinnick and Howells
298 Markham Street, 2nd floor
Toronto, Ontario M6J 2GB
Canada
www.dinnickandhowells.com

EKH Design
30 Boronia Street
Redfern, Sydney NSW 2016
Australia
www.ekhdesign.com.au

Elizabeth Resnick Design
126 Payson Road
Chestnut Hill, MA 02467
elizres@aol.com

F3 Design
P.O. Box 948
Crystal Lake, IL 60039
www.f3design.com

Falco Hannemann Grafikdesign
Steckelhörn 9
20457 Hamburg
Germany
www.falcoh.de

Fellers Marketing and Advertising
623 Congress Avenue, Suite 800
Austin, TX 78701
www.fellers.com

Fitch
10350 Olentangy River Road
P.O. Box 360
Worthington, OH 43085
www.fitch.com

5D Studio
20651 Seaboard Road
Malibu, CA 90265
www.5dstudio.com

Format Design
Steckelhörn 9
20457 Hamburg
Germany
ettling@format-hh.com

44 Phases
8444 Wilshire Boulevard, 5th Floor
Beverly Hills, CA 90211
www.44phases.com

Fossil
2280 N. Greenville Avenue
Richardson, TX 75082
www.fossil.com

Gee + Chung Design
29 Bryant Street, Suite 100
San Francisco, CA 94105
www.geechungdesign.com

Get Smart Design Co.
899 Jackson Street
Dubuque, IA 52001-7014
getsmartjeff@mwci.net

Giorgio Davanzo Design
232 Belmont Avenue E, #506
Seattle, WA 98102
www.davanzodesign.com

Grafik Marketing Communications
1199 N. Fairfax Street, Suite 700
Alexandria, VA 22314
www.grafik.com

GraphicType Services
24 Sherwood Lane
Nutley, NJ 07110
www.graphictype.com

Greenfield/Belser Ltd.
1818 N Street NW, Suite 110
Washington, DC 20036
www.gbtltd.com

Gregory Thomas Associates
2812 Santa Monica Boulevard, Suite 201
Santa Monica, CA 90404
www.gtabrands.com

Group Baronet
2200 N. Lamar, #201
Dallas, TX 75202
www.groupbaronet.com

Group 55 Marketing
3011 West Grand Boulevard, Suite 329
Detroit, MI 48202
www.group55.com

HGV
46A Rosebery Avenue
London EC1R 4RP
United Kingdom
www.hgv.co.uk

Hornall Anderson Design Works, Inc.
1008 Western Avenue, Suite 600
Seattle, WA 98104
www.hadw.com

IE Design
1600 Rosecrans Avenue, Bldg 6B/#200
Manhattan Beach, CA 90266

JOED Design Inc.
533 South Division Street
Elmhurst, IL 60126
www.joeddesign.com

Julia Tam Design
2216 Via La Brea
Palos Verdes, CA 90274
Taandmm888@earthlink.net

KBDA
2338 Overland Avenue
Los Angeles, CA 90064
www.kbda.com

Kiku Obata and Company
6161 Delmar Boulevard, Suite 200
St. Louis, Missourri 63112-1203
www.kikuAbata.com

Kirshenbaum Communications
725 Greenwich Street
San Francisco, CA 94133
www.kirshenbaum.com

KROG
Krakovski nasip 22
1000 Ljubljana
Slovenia
edi.berk@krog.si

Lawrence and Brooks
12 Sheldon Street
Providence, RI 02906
Striedman@lawrenceandbrooks.com

Lewis Moberly
33 Gresse Street
London W1T 1QU
United Kingdom
www.lewismoberly.com

Lieber Brewster Design
19 West 34th Street, Suite 618
New York, NY 10001
www.lieberbrewster.com

Lowercase, Inc.
213 W. Institute Place, Suite 311
Chicago, IL 60610
www.lowercaseinc.com

Lunar Design Inc.
541 Eighth Street
San Francisco, CA 94102
www.lunar.com

MOD/Michael Osborne Design
444 De Haro Street, #207
San Francisco, CA 94107
www.modsf.com

Mad Creative
150 Chestnut Street
Providence, RI 02903
www.madcreative.com

Mek-Aroonreung/Lefebure
1735 N. Fairfax Drive, # 13
Arlington, VA 22209
pumm@erols.com

Metzler and Associes
5 Rue de Charonne
75011 Paris
France

Migliori Design
392 Rochambeau Avenue
Providence, RI 02906
miglioridesign@aol.com

Mires
2345 Kettner Boulevard.
San Diego, CA 92101
www.miresdesign.com

Mirko Ilic Corp.
207 East 32nd Street
New York, NY 10016
(212) 481-9737

Misha Design Studio
1638 Commonwealth Avenue, Suite 24
Boston, MA 02135
www.mishalenn.com

Mix Pictures Grafik
Weihermatte 5
Ch-6204 Sempach
Switzerland
www.mixpictures.ch

New York City Technical College
300 Jay Street, N325
Brooklyn, NY 11201
(718) 260-5930

Niklaus Troxler Design
Postpach
CH-6130 Willisau
Switzerland
www.mixpictures.ch

Palazzolo Design Studio
6410 Knapp
Ada, MI 49301
www.palazzolodesign.com

Parham Sanatana
7 West 18th Street, 7th Floor
New York, NY 10011
www.parhamsantana.com

Red Canoe
347 Clear Creek Trail
Deer Lodge, TN 37726
www.redcanoe.com

re:public
Laplandsgade 4
2300 Copenhagen, K
Denmark
www.re-public.com

The Riordon Design Group
131 George Street
Oakville, ON L6J 3B9
Canada
www.riordondesign.com

Sagmeister Inc.
222 West 14th Street
New York, NY 10011
ssagmeiste@aol.com

Segura Inc.
1110 N. Milwaukee Avenue
Chicago, IL 60622
www.segura-inc.com

Sommese Design
481 Glenn Road
State College, PA 16803
lxs14@psu.edu

Studio GT&P
Via Ariosto
5-06034 Foligno, PG
Italy
www.tobanelli.it

Supon Design Group
1730 M Street NW, Suite 600
Washington, DC 20036
supon@supon.com

2GD/2graphicdesignAPS
Wilders Plads 8A
DK-1403 Copenhagen
Denmark
www.2gd.dk

Via Group
34 Danforth Street, Suite 309
Portland, ME 04101
www.vianow.com

VSA Partners
1347 South State Street
Chicago, IL 60605
www.vsapartners.com

The Works Design Communications
401 Richmond Street West, Suite 350
Toronto, ON M5V 3A8
Canada
www.worksdesign.com

WorldSTAR Design & Communications
4401 Shallowford Road, Suite 192/552
Roswell, GA 30075
worldstar@minds

About the Authors

Karen Triedman teaches color, applied color, and the psychology of color, design, and visual merchandising at Rhode Island School of Design. She has written on design, art, and color for local newspapers and magazines and has also reviewed artists and design books. Karen does consults in the areas of visual marketing and color design. Clients have included Swarovski Silver Crystal, New England Development Co., Paramount Cards, Card$mart, and Foxwoods Casino.

Cheryl Dangel Cullen is a marketing and graphic design consultant who writes for several major graphic design publications. Her books include *The Best of Annual Report Design*, *Large Graphics*, *Small Graphics*, *The Best of Brochure Design 6*, *Then Is Now*, and *Promotion Design That Works*, all from Rockport Publishers. She lives outside Chicago.

Leatrice Eiseman is an internationally recognized color specialist who heads the Eiseman Center for Color Information and Training, and she is the executive director of the Pantone Color Institute. She is widely quoted in the media and is the author of several books, including *Color for Your Every Mood* and *Pantone Guide to Communicating with Color*. For more information on Leatrice, visit her Web site at www.colorinstitute.pantone.com.